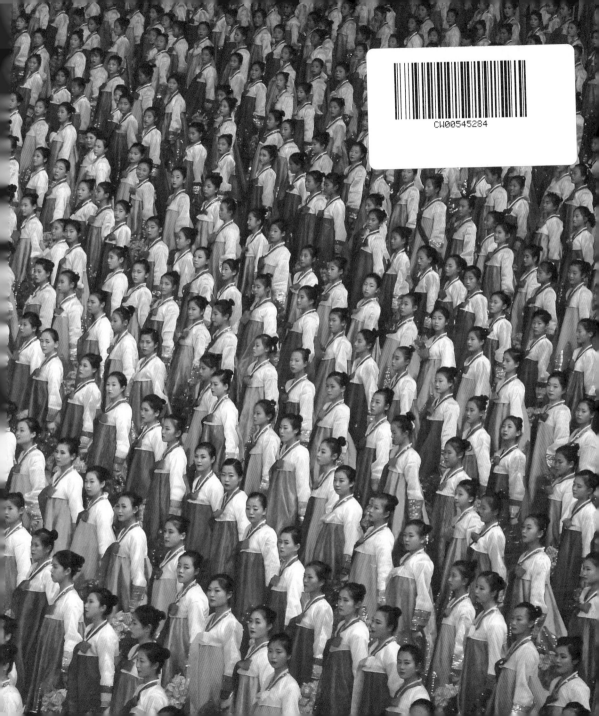

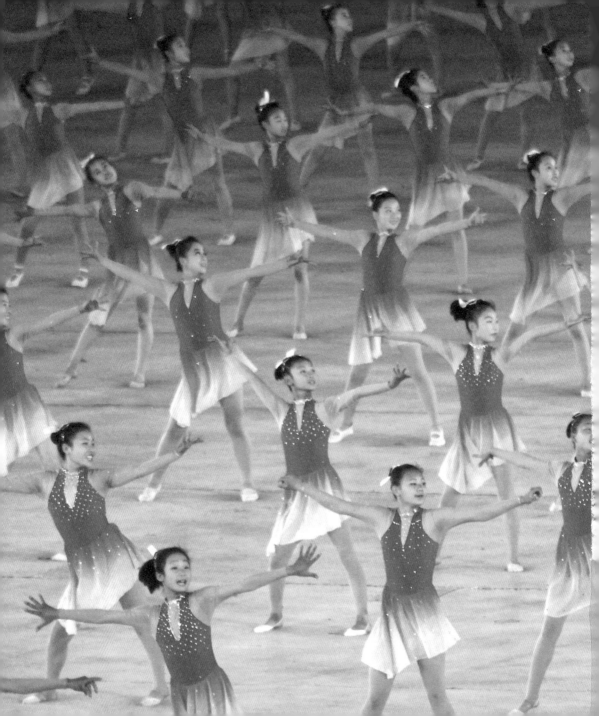

NORTH KOREA
Like Nowhere Else

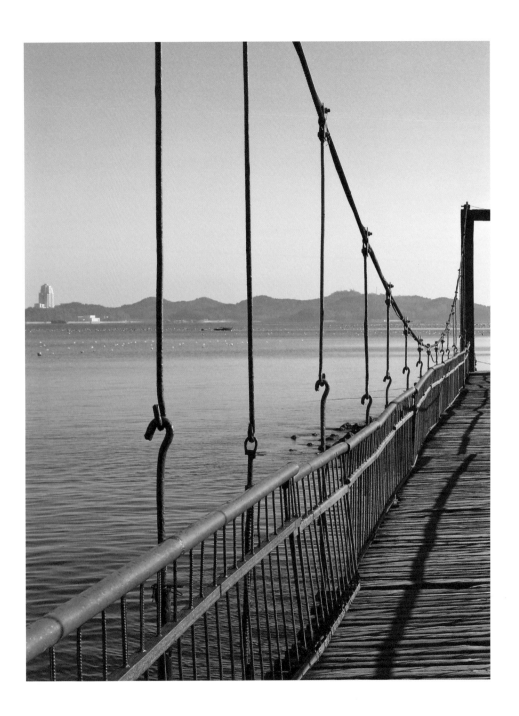

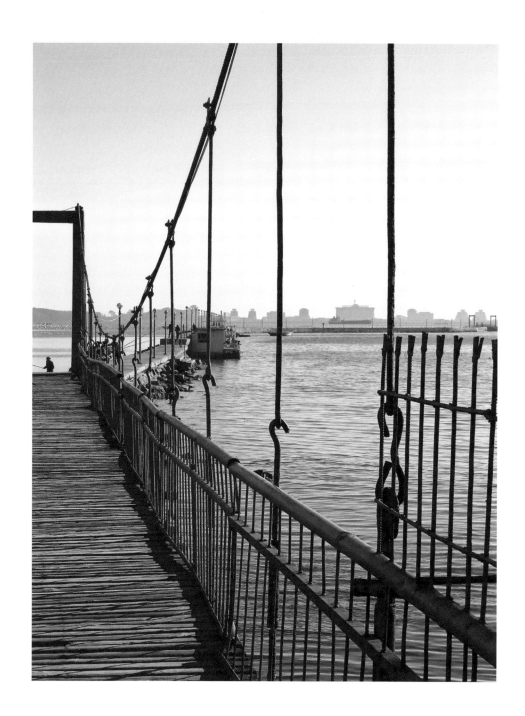

To the North Korean people I know and to
those I have never met. I will never forget you.

10 9 8 7 6 5 4 3 2 1

First published in 2021 by September Publishing

cover images:
(*front*) 70th anniversary of the founding of the country parade. — Pyongyang, September 2018
(*back*) Upstairs and downstairs. — Pyongyang, September 2018

endpaper images:
(*front*) The 2018 Mass Games. — Pyongyang, October 2018
(*back*) The 2019 Mass Games. — Pyongyang, August 2019

Design and sequence by Friederike Huber

Printed in Poland on paper from responsibly managed, sustainable sources
by Hussar Books

ISBN 9781912836802

September Publishing
www.septemberpublishing.org

**TWO YEARS OF LIVING IN THE
WORLD'S MOST SECRETIVE STATE**

NORTH KOREA
Like Nowhere Else

LINDSEY MILLER

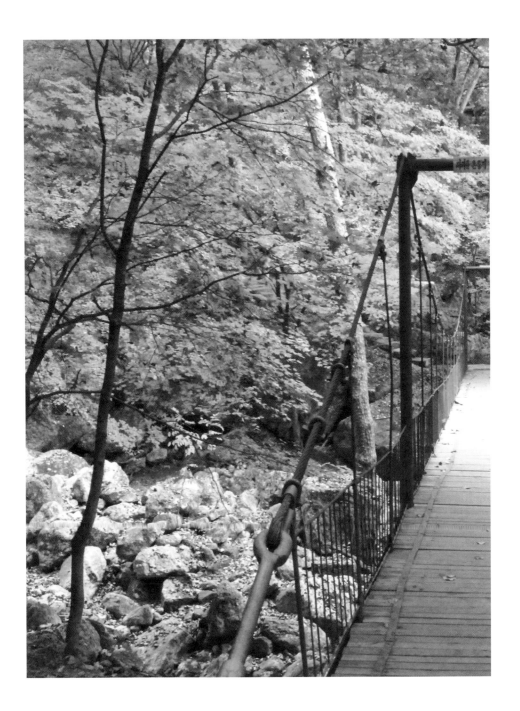

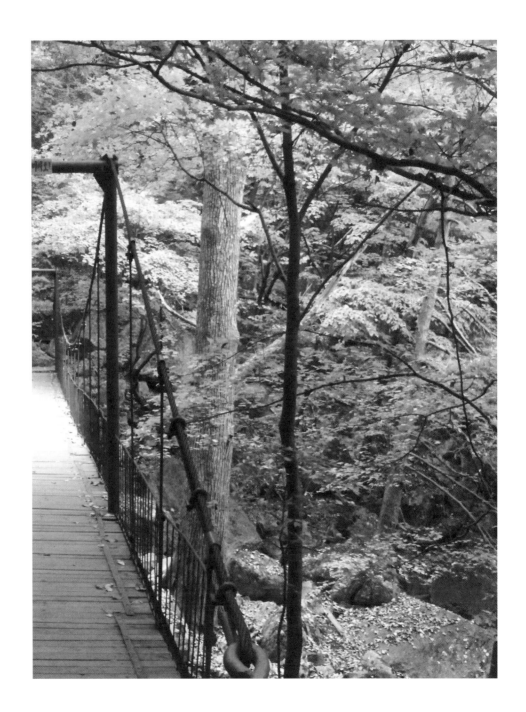

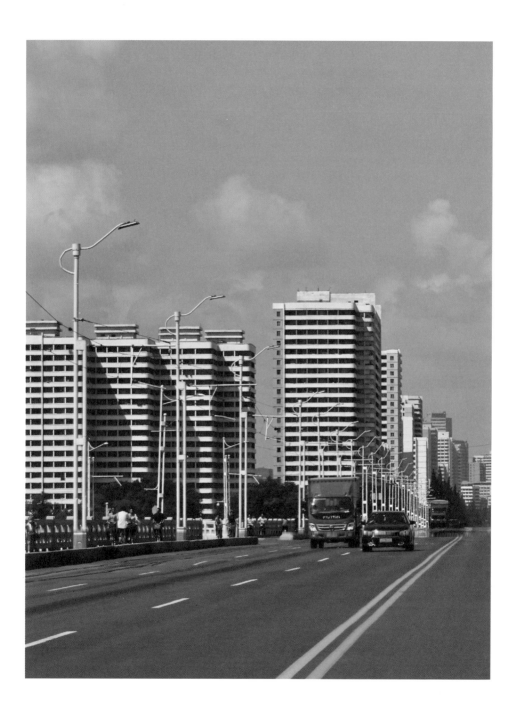

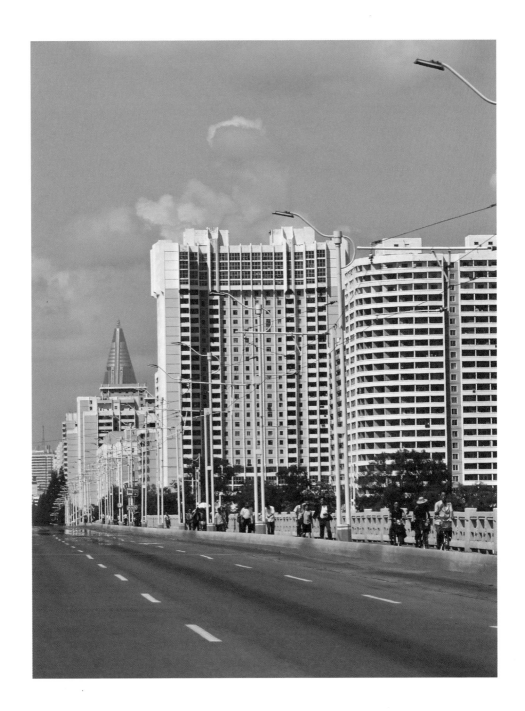

'We must envelop our environment
in a dense fog, to prevent our enemies
from learning anything about us.'

Kim Jong Il

INTRODUCTION

How much can you really know a place?

Many of us try to learn about foreign countries and people by trusting what we see in front of us. We learn from our experiences, what we can sense, what we feel: our most basic instincts. We also consider the opinions of others, using them to inform our own. From something unknown we feel like we start to understand.

But what happens when you go somewhere where even basic truths are ambiguous; where sometimes you can't trust your own eyes or even what you feel; where the divide between real and imagined is never clear? Are some places simply condemned to be beyond our understanding?

I found myself tormented by these questions for two years when I moved to North Korea in 2017 to accompany my husband on a diplomatic posting to the British Embassy in Pyongyang. Before I arrived I knew that North Korea was a place where foreigners were routinely arrested for relatively minor crimes, occasionally with dire consequences. I knew that a pervasive cult of personality subsisted on air-lifted lobster and caviar, while most of the population was condemned to beggary and misery. Depending on who I asked, there were 100,000 to 250,000 people languishing in prison camps. And, yes, I'd seen the footage of goose-stepping soldiers, Cold War-style military parades, ballistic missile and nuclear tests, and the almost comedic, profound yet ultimately inconsequential, otherworldliness of the place. But I had no idea what to expect, and no sense of how North Korea would change my life forever. Moving to North Korea turned out to be the biggest leap I'd ever taken. If I live for a hundred years, it's unlikely anything will surpass it.

Four months after I had decided to go, I stepped into North Korea's hot and muggy summer air for the first time. I stood at the top of the small and rickety airplane stairs and breathed in my surroundings, accented with the smell of pine trees, plane fuel and the cigarette smoke emanating from the cockpit. As I took in the desolate concrete runway and listened to several soldiers berating

(*previous pages*)
A wooden bridge leads to a pier. — Wonsan, October 2018
A bridge takes hikers over a trickling stream. — Mount Myohyang, October 2018
The Chungsong Bridge. — Pyongyang, August 2019

the baggage handlers for something I couldn't understand, I had no idea that, over the next two years, what I'd always considered to be the clear line between truth and fiction would disintegrate entirely.

We lived in a compound in eastern Pyongyang's Munsu Dong district, where most of Pyongyang's tiny foreign community lived and worked. Within the larger Munsu Dong international compound, smaller compounds housed the accommodation blocks, embassies and offices that lined several streets. There were a couple of hard-currency shops, a handful of bars and a school attended by the children of foreign residents. We lived in the old German Democratic Republic compound, home to a mini-community of German, British, French and Swedish diplomats. The streets of the international compound were overlooked on all sides by the crumbling high-rise apartment buildings of East Pyongyang.

At the entrance to the compound was an armed soldier who stood on the corner watching every car coming in and out. Beside him was a conspicuous red telephone. Beyond, manned roadside guard posts appeared every hundred metres and around every corner. Whenever a car left the compound, in one sweeping wave, each guard picked up their phone to call the soldier. Upon a car's return, the same would happen, the phones following the car back to its destination. A camera pointed straight at the exit to our compound. I had the constant feeling of being watched.

There were several rules foreigners had to adhere to, and some restrictions were easier to endure than others. We were allowed to walk and cycle around the city by ourselves as we pleased, but with Munsu Dong being a twenty-minute walk from the city centre, and with so many leisure facilities, shops and restaurants being spread across the city, driving was much more convenient. After sitting a North Korean driving test, we could freely drive around the city. Taxis and the metro, however, could only be used if they were booked in advance and if we were accompanied by an authorised Korean, usually our interpreter. Buses were supposedly off limits, although some foreigners did manage to sneak on board. Trains could only be taken to certain places. It wasn't impossible to chat with Koreans on these trips, but they would often clam up when the conductors walked by.

North Korean won is a virtually worthless currency only used at local markets and in a few shops and restaurants. Hard currency was preferred. In most circumstances it was possible to pay in a combination of euros, Chinese RMB and US dollars. When a shop had no foreign currency to give back as change, won was always offered with an apology and a look of embarrassment.

We were free to travel to Nampo, Mount Myohyang and other locations without a minder. The military checkpoints at Pyongyang's fringes were simple to pass through and required no handing over of papers or stepping out of the car. However, for locations where a North Korean guide was required, such as Sinuiju, Wonsan, Kumgang or Kaesong, a little more liaising and exchanging of papers was needed. Anecdotes circulated about foreigners who had been able to flout these requirements, but I never believed them, especially regarding the far south of the country, where the checkpoints became more and more menacing the closer you got to the demilitarised zone.

There were other challenges and restrictions on day-to-day living, such as the lack of cash machines, reliable healthcare or a decent internet connection. Our Korean mobile phones would only connect to other foreigners' phones and our designated North Korean interpreter. Calls to a random Korean mobile number wouldn't work, and the signal from our usual mobile phone networks was completely blocked.

Every day Koreans would film me on their phones, or take photographs. Sometimes this was harmless and born out of simple curiosity, but usually a phone pointed at me (or a man in a suit showing up) was enough to shut down any meaningful interaction with other local people. I let it get to me too often. But as suffocating as it sometimes felt, some instances were so ridiculous they simply made me laugh.

One particular freezing afternoon I was out hiking with a friend. It was minus 15 degrees and we were dressed from head to toe in winter walking gear. Stopping to admire the view, we looked behind us to see two men in suits and leather gloves following us up the ice-sheened road. The men spent the next hour sliding around in their shiny black shoes, sometimes gripping on to each other to keep their balance, one falling over and probably gaining a spectacular bruise in the process. My friend even went over to help one of them back to his feet.

On another occasion, while eating in a restaurant, a friend and I heard a loud ringtone blasting from the windowsill next to us. We were the only people there apart from the waitress. The melody sounded like it was coming from a display of plastic flowers that was arranged along the sill. I ran my hand under the flowers and lifted them to see a bright blue phone lying there. The waitress hurried over to our table looking very embarrassed and picked it up, answered it and talked for a few seconds, before pressing a couple of buttons and setting the phone back down under the flowers. She went back to polishing

glasses as if nothing had happened. It didn't matter if some measures to keep an eye on foreigners came across as hapless. What mattered was that we felt watched and under control.

The effects of the isolation imposed on us in that environment were hard to deal with, but the more subtle restrictions, mostly regarding our interactions with Koreans themselves, was what had the most impact on me. Opportunities to develop anything beyond superficial relationships were scarce. The Koreans I interacted with were mostly those who worked in and around Munsu Dong: interpreters, cleaners, drivers, gardeners and other local staff, who were assigned to every organisation and could often speak at least a little English. Then there were the waitresses and shop girls who worked nearby, whose smiles and giggles gradually became a normal part of my day. Jobs that involved working around foreigners were coveted, so I assumed they were given only to Koreans whose families were regarded as most loyal to the Workers' Party and therefore of a sufficiently high social status.

As for having meaningful interactions with random Koreans around the city, this was next to impossible. It was clear that people were fearful of their exchanges with foreigners being misunderstood by whoever was watching. Many would ignore questions, keeping conversation to a minimum. Some would even ask us to leave. But even with the Koreans we saw every day on the compound, it was still hard to know where the line was between asking someone ordinary things about their life and prying; or whether a relationship with a North Korean was built on true friendship or a managed arrangement of control and surveillance.

I struggled with the loneliness that resulted from lack of truthful, human connection with local people. I think a lot of foreigners are able to glide through the experience of living in Pyongyang and come through emotionally unscathed. Indeed, it would have been possible simply to take Pyongyang at face value. It probably would have made for an easier life. But after a while, I couldn't dismiss the questions or the effect North Korea was having on me. Yet my annoyances paled compared to what was going on around us. Life became about reading between the lines, discerning what Koreans really meant, and watching them skilfully sidestep the rules and walls that defined every aspect of their existence.

North Korea's national history and present-day character is a story of survival at all costs. Whatever ideology or national narratives used to uphold the

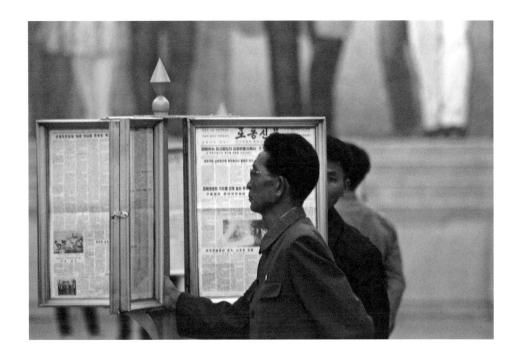

A man watches the tour group from behind a copy of the *Rodong Sinmun* in one of Pyongyang's metro stations. Koreans living in Pyongyang are the most exposed to foreigners; however, for many, it was still a new experience. I found Korean people to be very friendly, but spontaneous interactions were rare. As I found so often, a little longer of holding a gaze resulted in a smile and a friendly nod of the head. What often started as a look of confusion usually melted into a look of kindness. — Pyongyang, October 2018

legitimacy of the ruling family, it is presently held together by fear and control. Even in its most fraught moments, a flexible relationship with truth has ensured its survival.

The first example of this is the Korean War. Following the end of Japanese colonial rule at the end of World War II, the US and Soviet Russia were unable to reach an agreement on how the Korean Peninsula would be reunified. In 1948, two separate governments were created – the Republic of Korea (South Korea) supported by the US, and the Democratic People's Republic of Korea (North Korea) supported by Soviet Russia. Kim Il Sung, a young Korean Red Army captain who had spent many years fighting the Japanese in China, became the Soviet-designated premier, going on to become party chairman of the Workers' Party of Korea and leader of North Korea.

In 1950, his Korean People's Army (KPA) marched into South Korea in a bid to reunify the country under communist rule. The invasion resulted in years of devastating war for both sides. Fighting ended in 1953 with the signing of the Korean Armistice Agreement at Panmunjom. A formal peace treaty has never been signed, and the two countries technically still remain at war today.

This is not the version of history taught to North Korean children, however. To ensure the survival of North Korea, its leader and therefore its system, a new history had to be crafted. The war was renamed the 'Fatherland Liberation War'. Kim Il Sung was re-imagined as a mighty military leader campaigning to defend the peaceful Korean Peninsula from invasion by the US and South Korea. Through struggle and inspired leadership, Kim Il Sung brought victory – not near-defeat and stalemate – to his countrymen. That the US, and not Kim himself, had started the war underlined the national narrative that North Korea as a nation faced perennial destruction by its enemies, and only the Kim family could protect it.

A second example is that of the catastrophic famine endured by North Korea in the 1990s. Following the dissolution of Soviet aid in 1991, and combined with a horribly unbalanced allocation of national resources towards the armed forces, North Korea teetered on the edge of economic collapse. The public distribution system, a hallmark of the communist command economy, dried up. An estimated 3.5 million North Koreans were left to die of starvation.[1] Kim Jong Il, who took power in 1994, drew on his long career in propaganda and

1 Natsios, A. (2001), *The Great North Korean Famine: Famine, Politics and Foreign Policy*, United States Institute of Peace Press; illustrated edition.

narrative to rebrand the famine (which continued until 1998) as the 'Arduous March': just another bump on the road towards a perfect society.

Despite overwhelming evidence to the contrary, it was possible to argue that the famine had been caused by North Korea's foreign enemies, still intent on disrupting and imperialising their peaceful and humble land. I met plenty of North Korean people who would look me in the eye and blame South Korea and the West for the famine. Interestingly, even more would stress that its causes were 'complicated'.

Thirdly, North Korea's nuclear and defence programme, decried abroad as aggressive and reactionary, fits neatly into the regime's narrative that North Korean people should trust only themselves, and must be prepared for attack from its long-standing enemies. Under the current 'Supreme Leader', Kim Jong Un, North Korea has tested nearly three times the number of missiles than in the time of Kim Jong Il and Kim Il Sung.[2] I recall plenty of conversations with North Korean people able to explain the geopolitical realities of East Asia and why the nuclear programme was justified; I found it hard to imagine holders of the same professions in the UK able to do so. It was clear that the party's version of North Korea's place in the world, and its security dilemma, was well-learned from a young age by North Koreans who might be expected to encounter foreigners, or not. Some might think developing a nuclear programme is an awfully big risk to take just to provide anchorage for a national narrative. This is to misunderstand North Korea.

In each of these core examples, the Kim system uses myth as a powerful tool of survival. Its inevitable collision with reality made for the most fascinating moments of my time there, and I witnessed the effects of the country's strange dance between fiction and reality for myself many times. Although the machinery of government is completely closed to foreigners (and the vast majority of its own people), even the most mundane aspects of daily life required you moulding yourself to the alternative reality of a world held together by fear.

A Korean with whom I spent a lot of time over those two years was Min Jeong. She worked at a local bar called The Myohyang Beer House. Like many such places in Pyongyang, the Beer House wasn't just a bar: it had two restaurants,

2 Missile Defense Project, 'North Korean Missile Launches & Nuclear Tests: 1984–Present', *Missile Threat*, Center for Strategic and International Studies, April 20, 2017, last modified July 30, 2020, https://missilethreat.csis.org/north-korea-missile-launches-1984-present/.

two karaoke rooms, three bars, a gym and a hairdresser. Most foreigners drank in the downstairs room, which was essentially a makeshift bar in the lobby, next to a pool table. The entire building appeared to be run exclusively by a team of young, pretty North Korean girls who all spoke excellent English. Some also spoke Chinese or Russian. Most bars and restaurants in Pyongyang were staffed by females, which seemed odd in a system that trusted very few women to run anything. But here, the total absence of men did not mean that they weren't there: I found the long, heavy curtains covering many of the interior walls intriguing. No foreigner was allowed to go near them. My imagination ran wild about secret rooms full of men smoking and playing cards, idly perusing dozens of CCTV monitors. The notion sounds silly, of course. But had I found out this was true, it wouldn't have surprised me.

Min Jeong was one of several girls who worked and lived on-site, sleeping in dormitories in an area out of bounds to foreigners. They worked six days a week, with Sundays off to visit their families. What drew me immediately to her was her dry, sarcastic humour and droll nature. It didn't always go down well with customers and she was the butt of many jokes. Her tired expression contrasted grittily with the painted smiles worn by her colleagues: she'd had a lot of experience around foreigners and it showed.

The first time I met Min Jeong, she stared at me coldly as if she was trying to figure me out, slightly closed her eyes and grunted. She served my drink without a word, walked away and sat down on a little stool in the kitchen opposite the bar, took out her phone and started to scroll. She was in her own world. There was so much surface-level presentation of manners and politeness in this culture, especially in the presence of foreigners, that I found her rejection of this oddly magnetic. It was honest.

Over time we became careful friends and our conversations deepened. Min Jeong was always unexpectedly candid about how bored or fed up she was, how tired she was of being set up on dates by her parents or being told by her friends that she had to lose weight. She even went so far as to complain to me about some of the restrictions she endured. When I ran in the Pyongyang 10K she came to cheer me on, but at a distance from our mutual foreign friends. When I asked her why she didn't let them know she was there, she just looked at me, widened her eyes and shook her head. 'I couldn't,' she whispered. 'Too much security. Didn't you see all the security?'

On another occasion she told me not to trust the military guards manning the Munsu Dong guard posts because 'they lie all the time'. And I saw the

impact of local security on her for myself one evening, when I was walking to the bar and we passed each other outside on the street. I waved to her and shouted her name. She dug her hands into her pockets, looked at the ground and said nothing. The soldier assigned to stand on the corner opposite the bar watched as we passed each other in silence.

I generally found North Korean people to be very direct, in as far as their situation allowed, and it spanned the generations. Mr Ryu, an older friend of mine, never held back about his views on retirement. He had no interest in fishing or chess (typical pastimes of male retirees in North Korea) and loved working and 'feeling useful'. He didn't like Pyongyang much, either. He wasn't a city man and spent much of his time talking about his love of the countryside and his dream of living with his wife in a little house in the mountains surrounded by greenery and fresh air, not cars, people and pollution. Another friend, Mrs Hyeong, regularly updated me on the grumpy nature of her husband and her dwindling energy for her job, which she didn't enjoy much. A keen athlete when she was younger, she had felt dismayed at having no time to dedicate to her sport since she had decided to get married and have a family. She always asked to see photos of wherever I had been travelling and would spend minutes staring at every picture, zooming in to examine as much detail as possible. Hong Kong was a particular favourite.

My Korean friends were usually very forthright in asking me about my personal views on a range of topics, from British politics to which wife of Henry VIII I most admired. I usually avoided asking them about North Korean politics, but having conversations about complex issues wasn't totally impossible; it just took more careful consideration. I had several conversations with Korean friends about defectors living in London and British values of ethnic diversity, religious tolerance and the validity of same-sex relationships. Most of these subjects were usually met with looks of total confusion, but some things I'd imagined would be confusing in a closed country, like the borderless world of international consumerism, were quite straightforward.

These conversations fuelled my enduring belief that North Korean people know much more about the outside world than we might think. It's therefore likely that they have much more complex views on their own country than we might realise as well.

I always wondered if what we spoke about stayed with them after our conversations had ended. And while I was extremely fortunate to experience relationships with Koreans, the key question of how authentic our friendship

was always remained. I knew these interactions only happened because the system allowed it to be that way; that these relationships, while precious, were, ultimately, controlled. Was my friend Eun Mi asking me for my blood type to add to some sinister file the system was compiling on me, or was the question to do with – in South Korea particularly – blood type being a common way of determining someone's personality traits or working out if people are romantically compatible, like star signs are to some of us in the West? And when Mr Ryu, for example, told me about his life, was he building up my empathy for him so he could exploit it at some point? (This had happened to me before, when on the train from Dandong to Pyongyang. Three North Korean train conductors had made my acquaintance with tea and noodles before stowing countless packages in my cabin to avoid Customs.) How much could I really trust these people? This question would haunt me for the entire time I was there. I struggled to separate the human being in front of me from their environment.

In the end, I quickly learned that acceptance was far more sustainable than frustration. The only way I could feel at peace with my relationships was by dismissing what I thought I knew about the place and relying on my instincts. Most of the time, my instincts told me these interactions were genuine. And if the entire thing was completely false, that was fine too. It wasn't like it was their fault. They were just doing what they needed to survive.

While most of my Korean friends would probably never experience life abroad and could only get close to the outside world through foreigners, I met many Koreans who had had the opportunity to travel. I had been under the impression that North Korea was a prison where no one knew what was going on in the outside world, let alone travelled there, but that was far from the truth. The Koreans who had spent time overseas were easy to spot; they had a common curiosity and appetite for information. Still, it was only members of the elite, the privileged families of wealthy and powerful party officials, who had the confidence to ask questions and really engage. I encountered several groups of North Koreans travelling in and out of China for a multitude of reasons (some picking up a few bags of Starbucks coffee on the way). Others I met running businesses in Dandong, generating wads of foreign currency for the regime. Some had spent years studying in Russia, others in China, Poland or elsewhere. They were among the lucky few who were approved by the state each year to leave North Korea in an official capacity. Most of them were explicit about their longing to return abroad in the future.

But even if a Korean had the opportunity to leave, they were still subject to similar if not the same controls and surveillance that they would experience at home. Movements, conversations and internet usage were monitored. One North Korean told me that, when they were abroad, they weren't allowed to use their host country's subway system or freely organise their own activities outside work. It was hardly an escape. However, the exposure to the outside world would invariably undermine North Koreans' faith in their own system. In a bid to cauterise any weakness, those who returned to North Korea were placed under even more surveillance from the state security network than those who never left. But despite the regime's best efforts, I always felt that the eye-opening effects of foreign travel were irreversible. The openness and curiosity left behind from such a life-changing experience was easy to see when meeting a North Korean who had got out, even if it was only once.

During those two years, trying to understand what was real and what wasn't became the question with which I wrestled most. I had always imagined North Korea to be a sort of dystopian nightmare where everything was fake. In my mind, North Korea was a place of enduring falseness, with pristine, patientless hospitals; gleaming, studentless schools; and glossy leisure facilities nobody used. Most people are probably content with this image of North Korea – it is simple, easy to convey and confirms what lots of people already think. Of course the truth is more nuanced but, sometimes, I found myself right in the middle of a stock image of what I had pictured. Winter was one of those times.

Around late October, North Korea's lush, green countryside died away to leave little but a brown, frozen landscape. Pyongyang's roads became encased in thick, glassy ice. The crumbling chimneys of decaying 'harmonica houses' (so called because of their long, rectangular appearance resembling that of a harmonica) funnelled whatever smoke emerged from the fires inside. Lots of Koreans still hitchhiked on country roads, but vehicle traffic reduced to essential journeys only, and Pyongyang gradually limped to a standstill.

My first winter there, I noticed how shops and restaurants put up heavy curtains in front of their doors to keep in what little heat there was. Ice-cream stalls around the city turned into coffee stands and served hot steamed buns and cakes to shivering commuters. All over the city, workers in luminous orange jackets hacked at the icy ground with pickaxes, nothing covering their calloused hands but thin, woollen gloves. Some worked in small groups in the

middle of traffic junctions, battered by the freezing wind and toxic fumes from passing traffic. Away from the main thoroughfares, workers in poorer, residential districts carried on sweeping the streets with brooms made from twigs. Their efforts did little but polish the ice for cyclists, who slid around helplessly.

I'd often stare at the block of flats opposite my kitchen window. Many of the windows were taped over with layers of transparent plastic. When the dim light bulb of the top-floor apartment glowed at night, I wondered how those inside were coping in the cold. I'd read that families sometimes pitched a tent in their living rooms and huddled together on the floor, trying to absorb the heat from the pipes running under the tiles.

Like many people in the West, this is what I had thought of when I thought of North Korea: a very hard life lived in a miserable, barren landscape. But as I was learning, things were not that straightforward. Even in winter, although people struggled, in Pyongyang at least life went on. Many people found moments of simple joy in the unforgiving natural environment. I began to understand the simplistic inspiration propaganda artists could harness in conjuring their dogged, survivalist imagery.

Given little choice in the matter, the housewives of Pyongyang still came out to sing and dance to commuters every morning around the city, their summer dresses replaced by white, puffy winter suits. Parks were still busy with students playing football, now sporting trousers and long-sleeved shirts, and passers-by still stopped to watch and speculate on the likely victors, hands plunged into their jacket pockets. Grandparents took their children to local parks and pulled them around on sledges. In the snow, Kim Il Sung Square became a huge playground for snowball fights between families and groups of students. When the Taedong River eventually froze over, retired men, who usually spent long summer afternoons fishing in Pyongyang's ponds and streams, cycled across to the middle of the river, where they cut holes in the ice and sat all day on small stools, waiting for a catch. In the face of the most inhospitable conditions in this 'dystopian nightmare', ordinary life persisted.

I was learning that at least some of the narratives on North Korea encountered in the West were essentialist and simplistic. Yes, North Korean winter was bleak, but one Korean friend said they preferred it to summer, because the central heating in their apartment was more reliable than the air conditioning. Yes, the tours of children's camps were awkward and focused more on pictures

of Kim Jong Un's last visit than on the facilities available for children, but that didn't mean that children didn't actually attend them, and plenty of Koreans spoke with genuine warmth of their childhoods. Yes, theme parks and roller coasters were often empty and rusting, but that didn't mean they were all originally just built to impress or mislead foreigners. North Koreans did manage to have fun when foreigners weren't watching. These points sound somewhat glib now, but appreciating them fully was important to me at the time.

It was enough to encourage me to tear up the manual on understanding North Korea, often solely edited by YouTube sensationalism and eager journalists, and start again from scratch.

Perhaps unsurprisingly, the effects of living in such a confusing environment took its toll on me, and my behaviour changed dramatically over the course of those two years. It started with small, simple things. After only a few months, I stopped noticing the bright red and yellow propaganda. Portraits and murals of the Kims, which had raised my heart rate weeks after I arrived, also began to disappear into the background, becoming little more than markers for navigating the city. I was singing along to North Korean songs and not realising what the songs were saying any more, while the truculent battle cries in state media became as normal as weather updates.

More worryingly, from time to time, I would empathise with North Korea's propaganda. I would rationalise to myself the twisted behaviour of the system and somehow find myself buying into North Korea's claims of victimisation by the West. I'd read translated statements by North Korean state media and think to myself that it was perfectly understandable that they wanted nuclear weapons. Why wouldn't they when all they wanted to do was to protect themselves? After all, they were still technically at war with South Korea.

I couldn't explain why I had started to think that way. I certainly don't believe any of those things to be true. Maybe the propaganda was seeping into my subconscious, or maybe I was too drained from months of wrestling with my own thoughts to fight against it. I did know, when it got to that point of irrational reasoning, that it was time to get out for a break. The slow burn fatigue and isolation was palpable. It was never lost on me that millions of Koreans had no choice but to stay.

Anyone who has spent time in North Korea will agree that questions from people at home about life there are difficult to answer without reaching for superficiality or bluff. 'So, what's it like?' was a classic conundrum: where would

I begin? In answering that question, I could reinforce their views – or make them question what they thought they knew. For my family and friends, I was the only direct window into a world they would never see for themselves.

There was probably only a handful of diplomats or aid workers in Pyongyang who had the appropriate level of expertise to scratch the surface of what was really going on. But often they had spent a long, long time in Pyongyang, which brought along a different kind of bias – the kind that comes with fatigue and cynicism. I remember a very experienced aid worker, one week before departure, imagining his five years in North Korea as encountering a corridor full of doors, where each door he opened led into another identical corridor. Every now and again he had been able to open a door into an actual room, where he might learn something, but this was rare. His interpreter, hearing this allegory, agreed, and noted that although he had probably opened more doors during his lifetime, the result was more or less the same. The more time you spent in North Korea, the more you realised the extent of your own ignorance.

Expats found themselves showered with attention in their own countries, and could present their narrow experience of North Korea as universal truth. I saw it happening frequently. It would usually be most obvious when people had returned to Pyongyang from trips back home, where they had been inevitably the most interesting guest at a dinner party. Many returned as if they were a hero of their own story. Mainstream media was also not immune from dining at the trough of ear-catching but totally bogus Pyongyang expat prattle. For example, a foreign student studying at a university in Pyongyang penned an article in a major British newspaper claiming that they were the only citizen from their country in Pyongyang. Due to the high premium on any slice of information coming out of North Korea, the statement was believed without question. In fact, there were several citizens from the student's home country living in the international community – the student just hadn't met them. But facts don't matter: North Korea is strange and, therefore, in the eyes of many readers, if a strange assertion is to be true anywhere, it is probably going to be true of North Korea.[3]

It was difficult for people at home to understand that their expectations of what we could experience there, what we could really know about the place, were far too high. North Korea had made itself difficult to understand for the

3 *The Propaganda Game*, dir. Álvaro Longoria, 2015.

last seventy years and continued doing a rather good job of it. And if most Koreans didn't completely understand how their own country worked, what hope was there for foreigners?

North Korea cast a strange spell on the foreigners who lived there; I called it the Pyongyang Effect. Many people's behaviour changed as a result of the unusual environment, and particularly their relationship with information. Within the international community, perfectly sensible and reasonable people became immensely protective over local knowledge and gossip. Information was weaponised, to be traded between foreigners as a powerful currency. By holding back, many people could feel like they knew something others didn't and kept themselves in the 'special club' of the few who 'knew'. This manifested itself in whispered conversations between diplomats in smoky bars – much the same as in the capital city of any unusual country – but what surprised me was its metastasis into entirely trivial areas of life: the location and names of bars, restaurants and gyms or the availability of foreign products for sale. Foreigners became almost North Korean about guarding information. I never really understood why this happened, but it was hard not to fall into the same bad ways. At first it was fun, 'discovering' places that others might not know about, but soon the triviality was too overwhelming to ignore. In the absence of the many distractions found in other cities, a lot of expat life circled around the same meaningless chit-chat, fuelling rumours, topping up egos and increasing tolerance to alcohol.

I remember once watching one diplomat berating his friend for refusing to tell him where he'd found a carton of coconut water in Pyongyang. The friend had discovered a shop that sold something that lots of people would want. But if he told someone where to find it, the whole community would know, and then the stock would be gone. He had information that others didn't have, and he wanted to protect it. Two well-educated, well-informed internationals were seriously jealous over the apparent hiding place of a non-essential commodity. I remember watching Min Jeong's face as she looked on: I was utterly, utterly ashamed at the display of Western triviality (my own included) in an environment that made me think about human life in much more fundamental terms.

The Pyongyang Effect and the mythology of North Korea also caused foreigners to act in strange ways towards Koreans. People would ferociously compete with each other so they could be the first person to educate their Korean hosts about Facebook, Amazon or Western democracy. I sometimes felt the urge to do the same. It was a natural instinct to want to share information

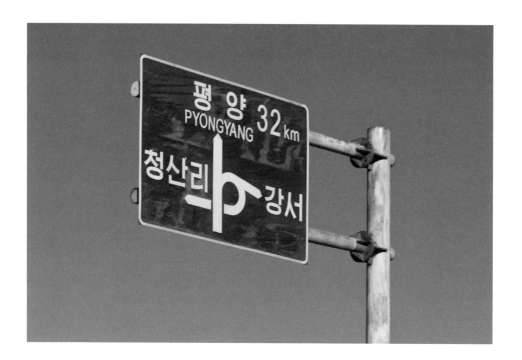

A hand-painted road sign for Pyongyang towers above the highway. In the grass verges there were always people planting crops or cutting grass by hand, and others repainting lines on the road with large paintbrushes. Many stopped to wave as I drove by. — Youth Hero Highway, September 2018

and feel like you were undermining the North Korean system of control in some tiny way. But we foreigners often failed to realise that the Koreans we were speaking to undoubtedly already knew the information we were so eager to impart and had probably been ideologically armoured against it, or at least were numb as to why they should care. Min Jeong told me once that she was fed up with hearing about Facebook and told one man to shut up when he kept going on about the free internet.

Many foreigners also wanted to be the ones who would finally be able to really change something in North Korea, and often they became completely blindsided by their selfish ambitions. One boasted about how he had been having a fling with a North Korean waitress and had discussed with her how she might escape. If it was true and that girl had been caught, who knew what would have happened to her. If it wasn't true and the girl was lying to play the unwitting foreigner, it would have been an abject lesson for everyone in how not to trust North Koreans – also damaging.

I was often disappointed that not all foreigners in Pyongyang treated their time there with at least some depth of awareness. I will never forget one senior figure among the Pyongyang international community who, when it was suggested that they should cherish their time in such an interesting and unusual place as it might someday change for ever, replied: 'Oh, I hope it doesn't change too much.'

This attitude was exacerbated by the tumultuous political period we were experiencing in North Korea at that time. Ordinarily, summers of tension would wind down as winter set in. North Korea's transformation into a desolate wasteland of ice and snow between December and February made moving people and things around the country quite tricky. If the regime miscalculated enough to provoke an actual response from the outside world during winter, it would quickly regret it. Most observers imagined casualties in a winter war would surpass a summer one, with starvation and disease not far behind. But 2017 was different: the tension was not part of a predictable cycle.

Despite UN sanctions and condemnation by most of the international community, North Korea wasn't about to stop testing its missiles and nuclear bombs. By the time I arrived in June 2017, they had already conducted a nuclear test earlier that year and launched several short-, mid- and intermediate-range missiles. I heard their first intercontinental ballistic missile (ICBM) test in July. Unlike their previous hardware, this ICBM was capable of striking targets

in the US, causing alarm in Washington and driving the North Korea problem firmly into the headlines.

After July 2017, political tensions worsened. In Pyongyang, anti-US propaganda was heating up dramatically. Editorials, essays, art, street signs and documentaries portrayed the crisis as North Korea being punished for trying to equip itself with the same basic self-defence technology long held by bigger, more powerful countries. It ranged from stirring paeans on self-reliance, resilience and the seemingly never-ending march to final victory, to targeted attacks on the immorality of sanctions as evidence of Pyongyang's victimisation by a hostile world. In return, Donald Trump was hurling anything from personal insults to outright threats of attack. It was difficult to see where the off-ramp was, especially as the inexperienced and impulsive US president seemed, for the moment, to be staking his foreign-policy credibility on the North Korea issue.

In Pyongyang, although Koreans went about their life as though nothing particularly significant was brewing in the world outside, the atmosphere was uneasy. It felt like someone was going to force a solution. A Korean friend told me they were worried about war breaking out. They looked at me expectantly, willing me to say something in response. Ordinarily, I would have insisted that the US didn't see North Korea as an enemy; I'd try and explain that it was their own propaganda exaggerating international responses to their own state's reckless behaviour – but it was becoming increasingly difficult to do that, given what was coming out of the White House.

The best thing I could think to do was to give them some information they wouldn't have learned from propaganda, such as the fact that open war between nations was a pretty rare thing these days. When all the authoritarian quirks of your country are justified as measures to protect you from invasion, it probably feels like war is the natural state of the world. I felt completely out of my depth trying to explain why this wasn't true. But it seemed to work. My friend looked at me for a few moments after I'd finished speaking. I wondered how much of what I told them they already knew. The dance continued.

That summer we watched, from our televisions in Pyongyang, as US President Donald Trump threatened to unleash 'fire and fury' on North Korea. Kim Jong Un replied with bizarre insults against the president. And on it went, back and forth, a decades-old powder keg being handled by careless schoolboys. One wrong step and things could have turned very quickly.

The international community was preparing evacuation plans in case

things got really bad. We were advised to pack a suitcase with clothes and other essentials in case we had to make a quick escape. But an escape wouldn't be quick. The only way to get out of North Korea was to fly to Russia or China from Pyongyang, drive to Russia or China through the northern provinces, which could have taken anything from four to twelve hours, or get a boat from Nampo or Wonsan. We knew all these options would pose problems. The military controlled how people moved around the country in peacetime, and I could only imagine how quickly limited freedom to travel would end if war were declared. If we didn't leave before the guns started firing, we'd probably have to wait out whatever there was to wait out. Many of us were under instructions to stock up on tinned food in case we had to hunker down.

It was hard to not be scared. The worry and stress I felt weighed on me like cold stone, but if it was worrying for me, a foreigner who had the choice to leave and had access to the outside world, what on earth must it have felt like to a Korean who knew very little and for whom there was no escape?

My questions kept coming and my unbridled anger towards the regime kept growing. How could they trade the well-being of millions of people for the survival of a system that was decrepit and broken? As time went on, my rage became twisted and misplaced as I struggled to understand. I started to feel anger towards the Korean people. How could they stand by and not do anything? Why didn't they challenge the injustice around them? I felt furious, too, with the international community. Their lack of influence on the situation was becoming starker. I could more or less predict exactly what the statements from various world leaders would say when they emerged. And it would make no difference. Kim Jong Un wouldn't care.

My thoughts grew even darker. I found myself energised by the prospect of a solution to the crisis being forced in some way. At one point, part of me started to want a war. The country would collapse and the human suffering would be untold, but so what? As for untold human suffering, what was in front of me already if not just that? My mind felt like it was rotting away. I felt like I was losing myself.

In 2018 things changed in ways I don't think anyone could have predicted. It started with Kim Jong Un's New Year speech, which spoke of engagement with South Korea for the upcoming PyeongChang Winter Olympics. Most importantly, Kim Jong Un spoke of sending a diplomatic delegation to the Games. Only months before the regime had detonated a nuclear bomb, fired missiles over

Japan and spewed threatening vitriol against historic enemies; now, it looked like some kind of normalisation was on the horizon, and potentially an end to Pyongyang's status as an international pariah.

As ever, the prospect of any kind of engagement by North Korea sent the world's media into a frenzy. Journalists, watchers, experts and the foreign community in Pyongyang longed for signs of a breakthrough, and for a while it felt like 2018 might be the year it finally happened. The world held its breath and hoped for the best.

The country's involvement in the Winter Olympics surpassed initial expectations. After several rounds of inter-Korean negotiations at Panmunjom, North Korea not only confirmed it would send an official delegation, but also that it would send athletes to compete. It would be the first time the country had participated in a Winter Olympics for eight years. Astoundingly, it was agreed North and South Korean athletes would compete together under a Korean unification flag, most notably the female ice-hockey players who formed a united Korea team. Cheer squads, performing arts troupes and North Korean pop stars also joined in. The delegation was, in effect, led by Kim Yo Jong, Kim Jong Un's sister and the first member of the ruling family to visit South Korea since the Korean War. She was accompanied by Kim Yong Nam, North Korea's titular head of state, who brought with him an invitation from Kim Jong Un for Moon Jae-in, South Korea's president, to visit Pyongyang. A second delegation containing Kim Yong Chol, a fearsome intelligence chief whose CV included ordering the shelling of a South Korean island in 2010, was seated in the same stand as an American delegation that included Ivanka Trump. The Games were hailed in the world's press as a huge success and lauded by the IOC president as a powerful symbol of peace.

It was the beginning of North Korea's attempts to reach out and capture hearts and minds. A few weeks later, Kim Jong Un travolled to Deijing to meet Chinese President Xi Jinping, supposedly the first time Kim had left the country since inheriting the leadership. It was a significant and quick shift in behaviour, a metamorphosis not many countries could have pulled off convincingly.

Even North Koreans were visibly taken aback by the change in events. One evening in the Beer Bar, I watched with Min Jeong as state news broadcast the details of Kim Jong Un's trip (days after it had actually happened, of course). She watched in stunned silence as her supreme leader stepped off a train in Beijing and waved to the hundreds of flashing cameras like some kind of movie star. Her eyes were wide and she was barely breathing. When

the broadcast finished, she turned to me, smiled, took my hands and shook them excitedly before scuttling away to grab her phone and start ferociously texting. Her emotion was infectious. Opportunities to see the world through the eyes of a North Korean were rare: if they thought this was a big deal, then it probably was.

A reconciliation with South Korea wasn't the only shift signalled by Pyongyang that spring. The United States, North Korea's lifelong enemy, would soon feel the charm offensive launched by Kim Jong Un, a notion previously unimaginable. Propaganda slogans around the city, which had for decades encouraged the nation's defiance against imperialist enemies, were replaced with more neutral expressions of 'togetherness' and musings on socialist construction. Propaganda posters depicting American soldiers defeated by North Korean weapons and the US Capitol being destroyed by North Korea's iron fist were gradually replaced with imagery of scientists, students and workers leading the country towards a better future. With the odd exception, state media dialled down its aggressive language. Shops stocking postcards and stamps for tourists suddenly ran out of the angry, anti-American designs, to be replaced by benign pictures of farms, fishing and factories. Enormous united Korea flags and banners appeared, draped over the sides of important public buildings in central Pyongyang. I saw plenty of commuters wearing united Korea T-shirts with the 'We are one' slogan. At the time, it felt like anything could happen. The city felt freer and calmer, as if a heaviness was lifting from people's shoulders.

Despite the persistent opiate of positivity and hope, I still often found myself doubting the sincerity of the whole thing. I couldn't bring myself to believe that rapprochement was a real objective for the North Koreans. Where would it lead? Was there a genuine desire to foster goodwill? This place didn't operate like that. Everything and everyone was playing a game to survive. And whatever progress was made, eventually we would arrive at the issue that had divided the peninsula for almost three-quarters of a century: neither would agree to being ruled by the other. If there was going to be real peace, something would have to give. And surrender was not part of North Korea's DNA.

Like everyone, I was desperate to see what kind of outcome the Singapore Summit of 2018 would bring, but I was also fascinated to observe how North Korea might conduct itself as a legitimate country rather than a personal fiefdom sustained by thuggery and cruelty. It wasn't as if Kim Jong Un had much

experience in dealing with world leaders, let alone an American president. But yet again, North Korea had held out the bait and I, like the rest of the world, was only too willing to bite.

It was astonishing to see the reaction from the international community in Pyongyang. Despite no one actually knowing North Korea's true intentions, most people were already convinced that real change had arrived. The summit fuelled the fire of optimism among expats, and across Pyongyang there were many evenings of celebrations and toasts to North Korea's peaceful future. A few old-timers pretty quickly dismissed the summit as a stunt. They were mostly ignored by the majority of the community as jaded party poopers who needed a rest, had been in Pyongyang too long, or whatever else. Most of the international community preferred to subsist on the dopamine of being at the heart of the action at a time of great change.

But the nay-sayers had a point. They had been calling out North Korea since the PyeongChang Games, highlighting some details of the new developments that seemed to escape the gleeful headlines. For example, North Korea hadn't just decided to take part in the Winter Olympics because it had had a change of heart and was now driven by the prospect of peace. North Korea had been endorsed by the International Olympic Committee (IOC) and provided with accommodation, travel costs and specialist equipment in order to increase its chances of qualifying. Even with extra support, the country had failed to qualify on its own merits. Instead of being eliminated, it was given a wild card which had been put in place to ensure that, if no North Korean athlete qualified, they could still participate. The whole thing was rigged so that North Korea received applause for just showing up.

Likewise, for the Singapore Summit, and in the months of diplomatic manoeuvring ahead of it, the world applauded North Korea's diplomats and negotiators for turning up – having their expenses paid, whilot offering very little in the way of actual concessions or proposals. It was rather like a disowned and disgraced family member appearing drunk at a Christmas party, trashing the house, insulting the guests, and being lauded as a hero afterwards just for being there.

Kim Jong Il's response to South Korea's Sunshine Policy of the 2000s, whereby South Korea aimed to warm relations with the North through political engagement rather than isolation, had been in line with this strategy of superficial but sufficient diplomatic engagement: extracting as much as possible in exchange for next to nothing. The elder Kim's analysis of North

Korea's diplomatic situation is believed to have been that 'the US will buy any lie, as long as it is logically presented; Japan is susceptible to emotional manipulation; and South Korea can be ignored or blackmailed.'[4]

This was certainly not the first time North Korea sought to redirect a crisis of its own making in order to shore up its precarious instability, and it wouldn't be the last.

September 2018 saw the eagerly awaited 70th anniversary of the founding of the Democratic People's Republic of Korea. While a big anniversary may have ordinarily been a chance to show its military might, that year was different. It was a chance for North Korea to crystallise its new narrative of diplomacy and friendship. The whole world was watching.

I'd never seen so many people from so many countries in Pyongyang at once. The airport's normally empty arrivals and departures board was now packed with additional flights, some to the same hubs like Beijing and Vladivostok, some to new connections like Vietnam and Laos. There were even rumours of someone having to wait around for a parking space at the airport – something I could never have formerly imagined happening at the country's ghostly gateway for foreigners. The traffic around Pyongyang was becoming busier too, with convoys of sleek black cars and more tourist buses packed with visitors eager to be in the country at such a special time.

The government exerted huge efforts in coiffing its capital for the incoming visitors. While the propaganda was being cleaned up, so were Pyongyang's streets. Roads were relaid, most notably parts of the airport highway, so visitors' first experiences of North Korean roads would be smooth. Buildings were repainted; shops were clad in mirror-like glass and stocked with even more imported luxury items than usual; huge frames with lights and freshly painted designs were installed to display propaganda posters; colourful flower displays were planted; and fancy lighting installations were fitted. Even the Mass Games – an enormous music, dance and gymnastic display held in the Rungrado May Day Stadium – was relaunched after a five-year hiatus with a show entitled 'The Glorious Country'. The editorial neutrality of state propaganda was deafening – and unnerving – showing North Korean people dancing, singing and clapping in praise of a new era of engagement.

4 Jang, Jin-sung (2015), *Dear Leader: From Trusted Insider to Enemy of The State, My Escape from North Korea*, Rider Publishing.

The big ideas of 'peace' and 'reunification' played out to receptive audiences all over the world and, up until 2019 when I left, the journey to what seemed like a new future continued. But if hope and optimism were engineered by the regime to distract the world from what was really going on under the surface, that only worked if the audience were totally blind to the cracks.

Ordinary life kept ticking along. I was still listening to Korean friends complaining about how tired they were from work, watching families having parties with their karaoke machines at the beach, seeing fights breaking out after closing between friends who had too much to drink, watching soldiers demanding ID cards from anxious faces, and the *inminbanjang* (the female heads of neighbourhood units) shouting at returning workers on the street.

At face value, perhaps, normality wasn't shiny enough to compete with the glittering headlines, but to me everyday reality was still the most fascinating thing to see and feel.

I had been taking photographs since the day I arrived. It started out as a simple hobby, but picking up my camera quickly became second nature after I realised how much photography was helping me to express myself and the complexity of what I was seeing around me.

As with other countries, North Korea had its own rules about public photography. No foreigner was allowed to venture into a North Korean's home and so opportunities were kept to public spaces. This made taking portrait shots especially difficult but not impossible, and I have included a few of my most cherished portraits in this book. In contrast to the restrictions placed on tourists, I never experienced anyone, official or otherwise, telling me off or censoring my material. But I was always aware that that didn't mean it was a complete free-for-all, and each situation had to be dealt with appropriately and sensitively. I'd seen far too many tourists shoving their cameras in Koreans' faces, leaving the poor person stunned and annoyed at another negative experience with a foreigner. For that reason, it took me a while to build up my confidence when wanting to capture something or someone. As with my conversations with locals, I took my role as a foreigner in their country seriously and I wanted Koreans to have a positive experience. I also didn't want to put them at risk because of my actions. They were human beings and I wanted to respect them. That was the very least they deserved.

My focus has always been, perhaps naïvely, to try to understand the complexity of what is beneath the surface. The shiny buildings and murals were

exotic and interesting, but the novelty of those gradually ebbed away. The eyes of the people around me, their everyday lives, was where I wanted to become lost and absorbed. After a few months, I realised that my photographs weren't just highlighting life and people as I saw them; they were also showing how much Pyongyang and other areas were changing: hairstyles, fashion, buildings and agriculture may have felt like they were stuck in time, but that didn't mean they didn't alter in very small ways.

I was also able to photograph what the Pyongyang I was seeing was like behind the propaganda. After the November 2017 nuclear test, for example, I stood with Koreans in the street and watched the announcement on the big screen by the train station. I photographed the curious but slightly confused throng of commuters, while the organised crowd in front of the state media jumped and clapped on command behind me.

Allowing my eye to go where it wanted, to focus on one thing, helped me become present and connect to where I was, instead of getting stuck in my head and missing it. Photography gifted me the small taste of freedom and control that I craved so much. My view, my art, was my own.

The legacy of what I captured really became apparent after I left Pyongyang in 2019. Leaving was a painful experience. I didn't want to go home, and the guilt from feeling so attached to somewhere like North Korea was something I struggled to understand. I still do. In moments of sadness, I felt like my relationships with North Koreans weren't real. In the whole time I lived there, I hadn't been able to ask any North Korean what I really wanted to ask them. While people around me in the UK often give the benefit of their opinion without being asked, I have never been so desperate to know what people thought about the world around them as when I was in Pyongyang.

The last conversation I had with my closest Korean friend played into this pattern. Even after two years of friendship, I couldn't break the wall. They still couldn't give the answers it felt like they wanted to give. I had tried to understand this country and desperately failed. But more than anything, the grief and definitiveness of leaving behind the Koreans I cared about was the most painful part. I knew I would never see or hear from them again.

When I returned to the UK I felt completely out of place. I felt like I was floating in nothingness. My home and friends were gone. I felt like I didn't belong anywhere.

It was then that I started looking back through my photographs. They cut

through the emotions of re-adapting to normal life and became a much-needed window into what I had left behind. I started noticing things I had never noticed before: little details that I had missed; people in the background or the tops of certain buildings. Photography allowed me to revisit moments in a way I couldn't at the time. The resulting photographs didn't always answer my questions, but they did give me more time to look for answers. I was able to step back into that lost world and look at it in a new light.

As the immediacy of my experiences slowly subsided into memory, the enormous burden I felt I had been accumulating and carrying for the last two years turned into a feeling of deep responsibility to share. I made the decision to collate my photographs and stories together into a book. I wanted to create an experience where someone else could feel what it was like to be immersed in such a strange, complicated and confusing country; where they could better imagine what it smells like on Mirae Street at three o'clock on a Tuesday afternoon in winter, or what the waterfalls sound like in the mountains; where they could feel what it is like to be stared at everywhere you go, and where they can know what it feels like to not be able to trust what is in front of you. Most importantly, I wanted to create something that would look through the military parades, tanks and murals, and connect with the kind, funny, creative, resilient North Korean people as I saw them.

North Korea is unique and everyone's experience of living and visiting there will be different. This book is only one person's account, and I have tried to present it with honesty and integrity. So much material that is written by foreigners who have stayed there feeds on exaggeration, dramatic stories of war and geopolitical tension, and ignores the complex yet at the same time mundane and instantly recognisable realities of everyday life. I have tried not to do that.

I'm not a North Korea expert, and certainly do not think that that this book will solve any mysteries. There are probably questions I've pondered in this book that other people will already know the answers to. Plenty of readers will dispute my observations and photographs, armed with statistics and analysis gleaned from afar. All I can do is try to tell the story of what it was like to live there, and offer sketches of the Korean people I was able to meet and get to know a little. I hope it helps in a small way to crack the façade of what the regime, or anyone else, would want you to believe about its people.

Living in North Korea has fundamentally changed who I am and how I see the world. It has forced me to confront some hard truths about myself and

made me strive to be a better person. I challenge anyone who's been there for an extended period not to look back with a complex cocktail of emotions. The difficulty I've found re-adjusting to life in the UK, and the emotions I still have, are a huge source of guilt to me, as these things are nothing compared to the experience of the North Korean people who have left or remain in the country. I still have anger that the regime endures. I long for the day when the North Korean people can have freedom, which they, just as much as any of us, deserve.

So, how much can you really know a place? Are some places simply beyond our understanding?

I leave it to you to make up your own mind.

Being a resident foreigner in Pyongyang revealed a view of North Korea seen only by the few who have also been privileged to experience the country in this way. These photographs are all my own and are part of a 12,000-strong collection covering 2017 to 2019. The majority of these photographs were taken without a minder or guide overseeing me, as I was free to move around and photograph in Pyongyang and other areas. The few included that were taken on tours to areas not otherwise accessible as an unaccompanied foreigner have been specified.

It was important to me to preserve the reasonable privacy of those I photographed, and to minimise any risk posed by my presence or actions. For this reason some of these photographs are taken from a distance. In intimate interactions with Koreans where I felt taking a photograph would have been inappropriate, I have instead written about my experience. I have also changed the names and details about Korean friends and acquaintances in order to protect their identities.

I never experienced any censorship of my work by North Korean officials or otherwise while in the country. I was never asked to delete or surrender any photographs to North Korean authorities.

Despite the freedoms we enjoyed in North Korea, there were many parts of the country we could not visit. Similarly, casually visiting North Koreans in their homes was strictly forbidden, and access to rural villages located beyond hard military checkpoints was rare. As such, it is important to note that any experience of North Korea will never be comprehensive.

I have chosen to refer to the North Korean people as 'Koreans' simply because this is how they refer to themselves, except where the meaning is unclear. For North Korean people, I have used the North Korean formatting for names, which rendered into English is different to that of the South. For South Korean people, I have used the South Korean format.

The poverty and physical suffering endured by the North Korean people at the hands of the Kim regime can only ever be known through their own stories and words. It is not my place to speak for them. This book aims to show life as I saw it in North Korea, as a foreigner, and is reflective of my own experience.

All photographs and opinions are my own and are not representative of the views of any other individual, organisation or government.

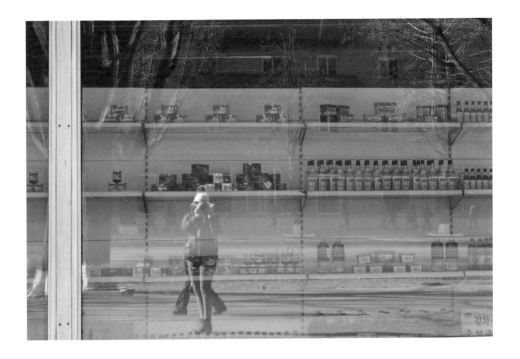

Standing in front of Pyongyang's Department Store No. 1's main display window.
Department stores are popular among the Pyongyang elite for shopping and browsing.
While plenty of new department stores have appeared in Pyongyang in recent years,
Department Store No. 1 is a tired monument to the rigid, planned distribution of goods
that defined North Korean life before the 1990s. — Pyongyang, January 2019

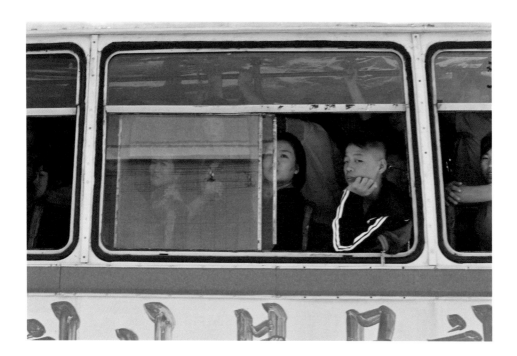

Like rush hour anywhere else in the world, commuters pack tightly onto buses for their daily journeys to work. The stifling summer heat meant that many fought for the window seats for some cooler air. — Pyongyang, September 2018

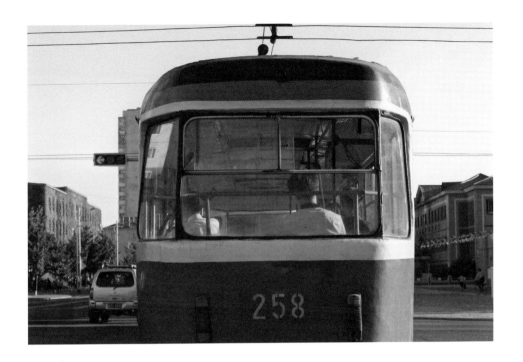

Soviet-style trams clattered along their routes throughout central Pyongyang. The fleet probably consists of Czech, Hungarian and Russian hand-me-downs. Korean friends often spoke of how their daily commute usually took much longer than a simple car journey would, due to constant breakdowns and late connections, which for one friend resulted in her regularly missing putting her baby to bed. — Pyongyang, September 2018

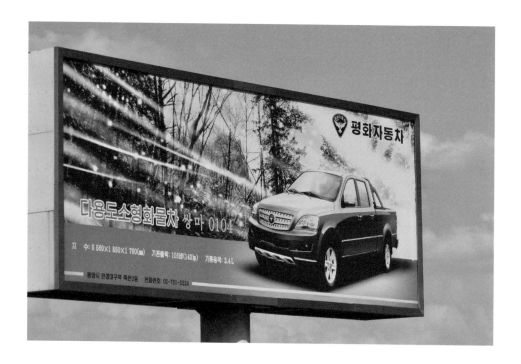

While these adverts for North Korea's Pyeonghwa Motor Company could be seen all over Pyongyang, the reality is that privately purchasing a car is impossible for the average North Korean. The Korean Workers' Party elite are taxied around the city in buffed black Audis and Mercedes. These vehicles drove around at incredible speeds, often careering aggressively onto the wrong side of the road. It made driving at night even more dangerous. — Pyongyang, August 2019

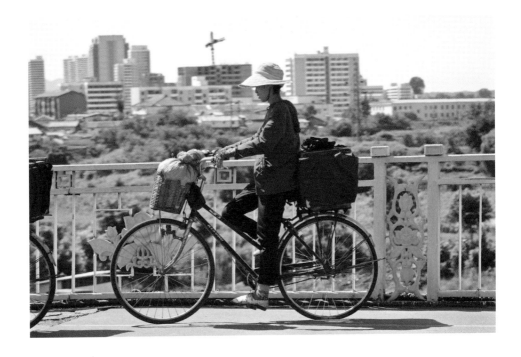

Bicycles are still the most common way of getting around in Pyongyang. In the summer of 2019, there were increasing numbers of Chinese-made electric bikes appearing around the city. At the time this photo was taken, an electric bike would have cost upwards of $250. I only ever saw them available in department stores, but some enterprising Koreans who didn't have the cash would likely have had ways of getting one.
— Pyongyang, August 2019

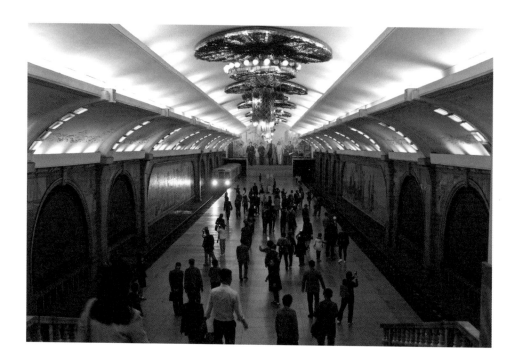

Commuters rush for the next train at Puhung Metro Station in Pyongyang. A more reliable (and cheaper) way for Koreans to travel is on one of Pyongyang Metro's two lines. The metro itself is the deepest in the world: at more than 100 metres underground, it is known to double as a bomb shelter. The echoing platforms reflect the light from the huge chandeliers and funnel the scent of stale air and pine-scented cleaning fluid around. The metro, as with most other public transport, was not accessible to foreign residents and this photograph was taking during a private guided tour.
— Pyongyang, October 2018

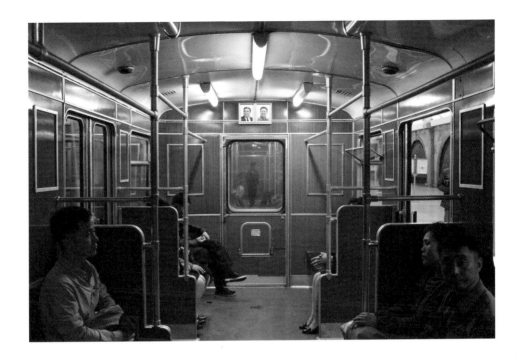

Most passengers sat in silence as the pristine former German *U-Bahn* carriages rattled along the tracks. Others read newspapers or books, or took out their phone to kill time between stops, playing the latest North Korean gaming apps. Shortly after this shot was taken a couple of schoolchildren sat down, playing a racing game on their phones. The games blasted music into the carriage much to the disgruntlement of the woman on the right who promptly told them to turn it down and stop being a nuisance. — Pyongyang, October 2018

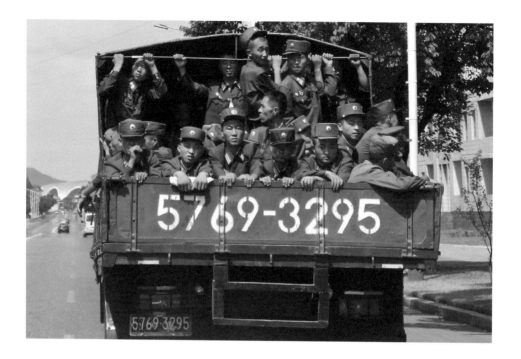

Soldiers could often be seen being transported on the backs of trucks – and ferried to construction sites. Soldier-builders provide a source of essentially free labour to the government, which partly explains why construction projects are often finished in record time. Shortly after taking this photograph, they all waved and started giggling and one flirtatiously blew a kiss. — Pyongyang, August 2018

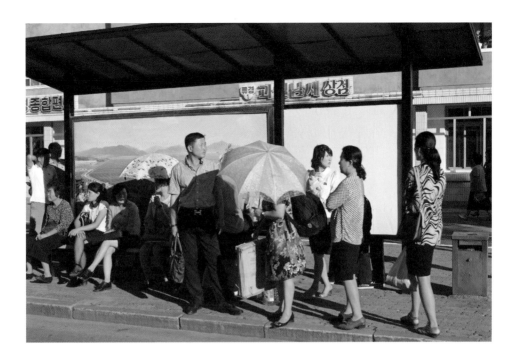

In summer, when temperatures could reach upwards of 40 degrees Celsius, most women in Pyongyang used decorated sequined parasols for relief from the sun. This woman waiting for the bus had struggled to open hers, much to the amusement of everyone waiting in the queue. — Pyongyang, September 2018

(*opposite*) A green fence hides the bottom floor of this smaller block of Pyongyang apartments, still under construction by soldier-labourers. It wasn't uncommon to see soldiers dangling over the edge of the building on a single rope, hammering or plastering the outer walls. I also saw one soldier demolishing the floor of a balcony with a hammer while still standing on it. The men work well into the night. In total darkness, the clinking of bottles, shouting and laughter could be heard on the roofs, sometimes followed by intense sparks from soldiers welding. Houses with surrounding land were planted up with crops such as corn. Here on the pavement to the left, the corn is left out to dry in the sun to then be stored for winter. — Pyongyang, September 2018

(*above*) Two Pyongyang taxis parked outside one of the city's many shops. Some car parks incurred a $1 charge – at least for foreigners – in this case payable to the man on the right of the photograph. A payment of 5,000 North Korean won (in 2018, roughly equivalent to 40 cents) was usually also sufficient. Taxis with a number plate ending in an even number operated on alternate days with those displaying odd numbers, so that both sets were never seen on the same day. I never found out exactly why. — Pyongyang, September 2018

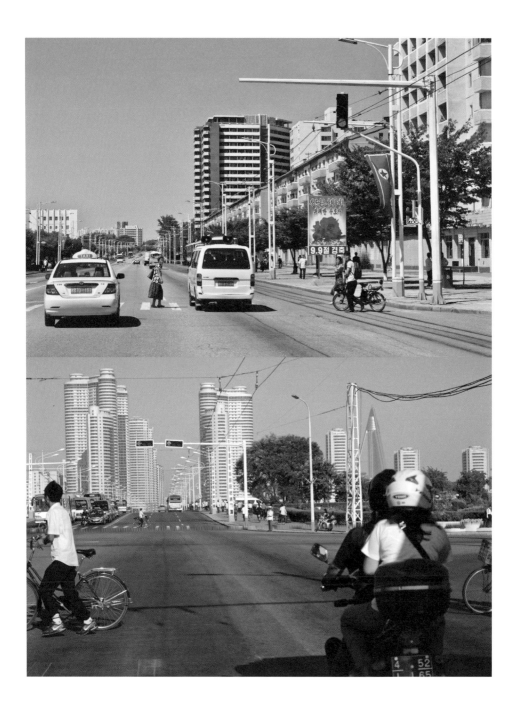

THE DRIVING TEST

'*Anyeongasimnika*!' shouted the driving-test examiner in greeting as he shook my hand, grabbing it so forcefully I thought he'd crush my fingers. His breath reeked of *soju* and his wide grin revealed a gold tooth, making him look like some kind of gangster.

The absurdity of having my driving examined by a drunk North Korean in North Korea nearly made me laugh out loud. I'd only been in Pyongyang for a few weeks and life was already unrecognisable.

In lieu of his real name, the nicknamed Mr Soju held the front passenger door open, apparently not noticing or caring that we were parked directly underneath a NO PARKING sign in front of the test centre. He said something in Korean, before cowering and looking at me wide-eyed, with a cheeky grin.

'He's asking if it's safe to get in,' laughed Mr Song, my interpreter.

I sat in the driver's seat with Mr Soju next to me, and Mr Song in the back. Mr Soju flicked on the radio and the Moranbong Band, North Korea's famous all-female pop group, started to play. As the synth trumpets tooted, I pulled out of the driving centre. I didn't know the Korean word for 'left' and 'right' and so I waited for Mr Song's translated directions. Unfortunately, by the time Mr Song translated Mr Soju's instructions, we missed the relevant turns, and Mr Soju and Mr Song were forced to communicate by gesticulating at each other – and me – while I drove. I was sure there was an excellent comedy sketch in there somewhere.

For the first half-hour I wasn't doing much more than driving forward and stopping for lights, but Mr Soju seemed pleased, judging by his frequent nudges and thumbs up signs. But then, quite suddenly, the atmosphere changed and the smile disappeared from Mr Soju's face. He opened his hand and started to move it slowly up and down. His brow was creased and his breathing deepened.

(*opposite top*) Despite little traffic, Pyongyang's roads could be tricky to negotiate, with pedestrians constantly jumping out in front of cars or standing with bicycles in the middle of the road. Road safety awareness was minimal. — Pyongyang, September 2018

(*opposite bottom*) A couple ride a motorbike towards Pyongyang's exclusive Mansudae district (known as 'Pyonghattan' to the foreign community). Many of the country's top elite live in these apartments, which were known to be privately sold for hundreds of thousands of dollars. — Pyongyang, August 2018

I checked my speed: nothing seemed to be wrong; I checked my lights: nothing seemed wrong. I kept driving the way I was, but Mr Soju became more irritated, shifting forward in his seat and moving his hand up and down faster and faster, his breath becoming more agitated.

'Slow down, Mrs Lindsey, slow down!' pleaded Mr Song from the back seat. I had been so focused on the road that I hadn't noticed that we were passing an enormous mural of Kim Il Sung and Kim Jong Il. I immediately braked and slowed. As Mr Soju grumbled, still waving his hand until I was barely moving, Mr Song explained that every image of the Kims had to be passed slowly and respectfully. Acknowledging the Kims wasn't compulsory only for North Koreans – foreigners had to toe the line as well.

We sat in the car in complete silence as Mr Soju nodded his head.

'Always slow down, Mrs Lindsey,' said Mr Song, somewhat embarrassed.

As the mural passed into the distance, I came to the last part of my test. I was told to turn in to an enormous empty car park behind a tired-looking sports hall. Encircling the car park was a single-lane road which twisted and turned, for no discernible reason, like a go-kart track.

'Drive forward at same speed then reverse at same speed,' said Mr Song. I was just about to hit the accelerator when the examiner got out of the car and opened my door. 'He wants to show you.'

Mr Soju ushered me to the passenger seat and I did as I was told. He cranked the driver's seat forward so that the steering wheel was almost pushing into his chest and slowly wrapped his nicotine-stained fingers around the steering wheel, relishing the moment as if he was about to drive off in his dream car. He turned to me and gave me a golden smile. Mr Song nodded in agreement. Off we went. Steadily he completed the course and patted his hands together at the end like Mary Poppins.

'He said he drives like a professional,' laughed Mr Song. 'Your turn.'

Mr Soju lifted his eyebrows and pointed at me encouragingly. I pulled the seat back to its original position and took my turn around the track. When I finished, I patted my hands together like he had done, and Mr Song and the examiner cackled like it was the funniest thing they'd seen all day.

Mr Soju tapped me on the arm and gave another big thumbs up.

'He says you are a very good driver,' said Mr Song. Mr Soju leaned over the gear stick and flirtatiously wiggled his eyebrows up and down. 'He says that's because you have the best driving examiner in all of Korea.'

One of North Korea's coastal cities, Nampo lies 50 km southwest of Pyongyang. Situated at the mouth of Pyongyang's Taedong River, it is the country's major west-coast foreign trading port, home to the Korean People's Navy's West Sea Fleet. It also has a naval shipyard and significant industrial complexes. And a beach, of course. At the entrance to the city, buses could be seen pulled up at the side of the road. Koreans wandered around, waiting for their ID cards to be checked and have their permission to travel confirmed by local police. — Nampo, August 2019

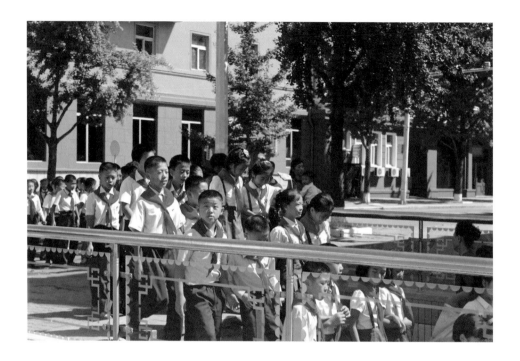

School children frequently passed through the streets of Pyongyang, holding hands and singing songs while on their way to bow to murals of the Kims, or visit one of the city's museums, water parks, cinemas or other leisure and education venues. According to a Korean friend, behaviour at schools, particularly among boys, was getting worse. Parents struggled to keep their children off video games and focused on completing their homework, meanwhile teachers struggled to control and discipline large classes of boisterous personalities. — Pyongyang, September 2018

Students ascend the steps in front of the mural and line up neatly before bowing together. Some brought gifts of artificial flowers – rumoured to have been resold to subsequent groups after their removal by wardens. All public images of the Kims, including portraits, are still produced by Mansudae Art Studio in Pyongyang. Established in 1959, and later run under the 'special guidance' of Kim Jong Il, Mansudae is so integral to the regime's production of propaganda that it enjoys ministry status among the North Korean government. Under order of Kim Jong Il, in 1970 it was compulsory for state-issued portraits of Kim Il Sung to be hung on the wall of every living room in North Korea. By 1972, this rule was applied to most public spaces like train stations, leisure facilities and government buildings. — Pyongyang, September 2018

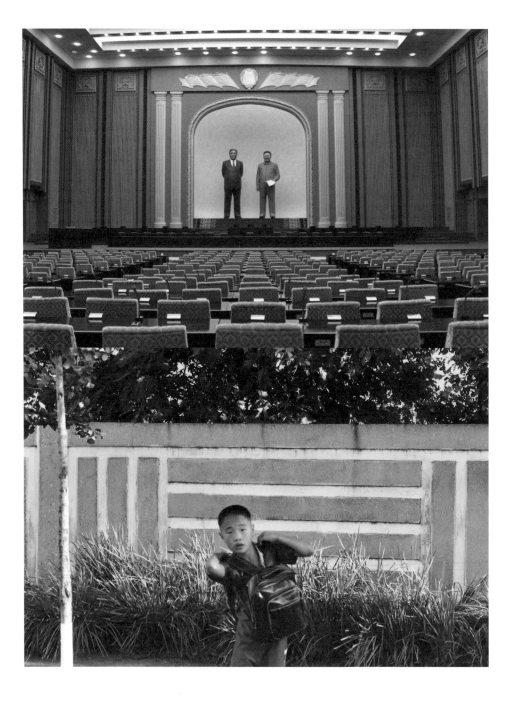

THE BOY AND THE MURAL

The enormous mural of North Korea's leaders leaned over everyone who passed it. In front of the mural were coiffed, bright green bushes and a small set of perfectly polished steps flanked by two solar-powered lights.

A little boy, not much more than five years old, was kicking a football around the wide pavement, just in front of where the mural stood. He was wearing blue shorts and a yellow T-shirt and holding a half-eaten bag of snacks in his right hand. He laughed as he jolted around, passers-by offering encouraging comments and giving high fives to the small player. Suddenly, the boy stopped his game, picked up his ball and walked up the steps. He carefully placed the ball and his snacks to one side and stood in the centre of the top platform. His tiny body was dwarfed by the enormous painted concrete wall. He patted down his T-shirt and shorts in preparation and, with his hands by his side, he stood tall and gave a deep bow to the dead leaders. He held his bow for a moment and paused when he rose, staring up at the two men that had such influence on his life.

His lonely ceremony over, the boy collected his ball and snacks and skipped back down the steps, dribbling the ball enthusiastically down the pavement, shouting to his imaginary teammates until he was out of sight.

My throat felt tight as I tried to understand what had been going through the boy's head. Had he been looking at his heroes? Or was he just doing what he needed to do to stay out of trouble? What did a life under North Korea's regime mean for this child? What unseen obstacles lay in his path?

Increasingly, I was waking up to how much I had blindly believed and trusted sources about North Korea before I arrived. I remembered seeing a documentary which talked about 'hundreds of people' visiting the murals in Pyongyang every day to bow, but so far, all I'd seen was that one little boy.

Was it because so few people came to North Korea that exaggerations were more likely to be believed than refuted?

(*opposite top*) Two wax statues of North Korean leaders Kim Il Sung and Kim Jong Il lean over an empty chamber inside the Supreme People's Assembly. — Pyongyang, January 2019

(*opposite bottom*) A young boy adjusts his school bag by the side of the road in Pyongyang. — Pyongyang, September 2018

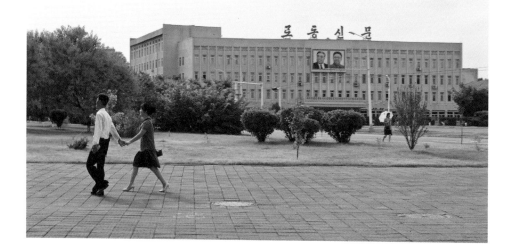

A young couple hold hands as they pass the *Rodong Sinmun* building, home to Pyongyang's daily newspaper. Frowned on by the older generation, public displays of affection among young couples were becoming increasingly common. The new generation of Pyongyang elite are behaving in ways that either ignore or challenge traditional cultural norms. — Pyongyang, August 2018

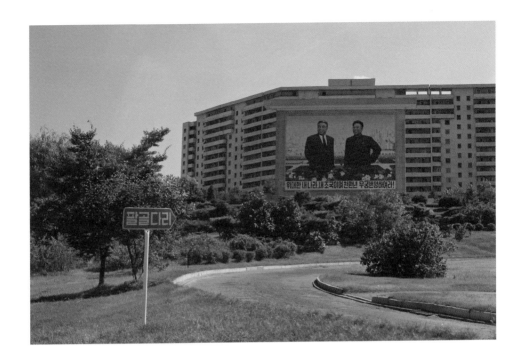

A sign for Palgol Bridge directs the road past a mural of the Kims and towards the main road out of Pyongyang and towards Nampo. In summer, Pyongyang's grassy spaces often featured middle-aged women tending the lawns or student work groups throwing water over the grass. — Pyongyang, August 2018

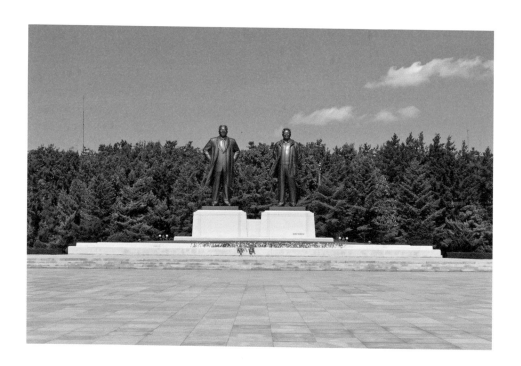

While many of us are used to seeing the enormous bronze statues of the Kims at Mansudae Hill in Pyongyang, these smaller versions are found on the main road through Nampo city. — Nampo, September 2018

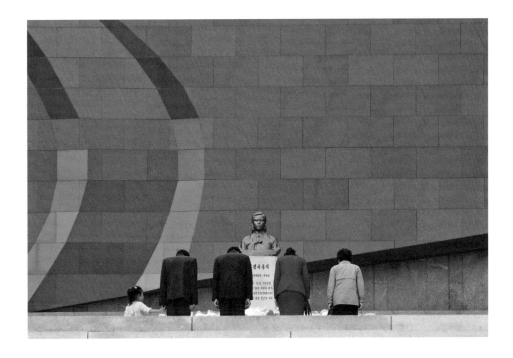

As orchestral music plays from speakers around the concrete steps at the Revolutionary Martyrs' Cemetery, a young girl holds the hand of her father as the family bows to a bust of Kim Jong Suk, the mother of Kim Jong Il and first wife of Kim Il Sung. In state mythology she is revered as a formidable anti-Japanese guerrilla and the 'mother' of the country. What did Kim Jong Suk mean to this little girl who only moments before was tidying her hair and dress in anticipation of bowing? — Pyongyang, August 2019

(*following pages*) Every time I went out into the city centre of Pyongyang, I made a point of going through Kim Il Sung Square. It was impossible to know when rehearsals for parades or other events were scheduled so it was always worth going to see if anything was happening. I saw many rehearsals and dancing for big events but most of the time the square was desolate. — Pyongyang, January 2019

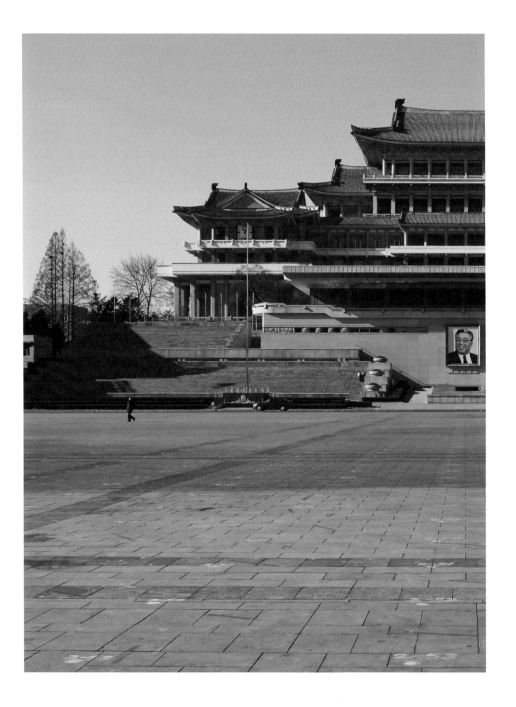

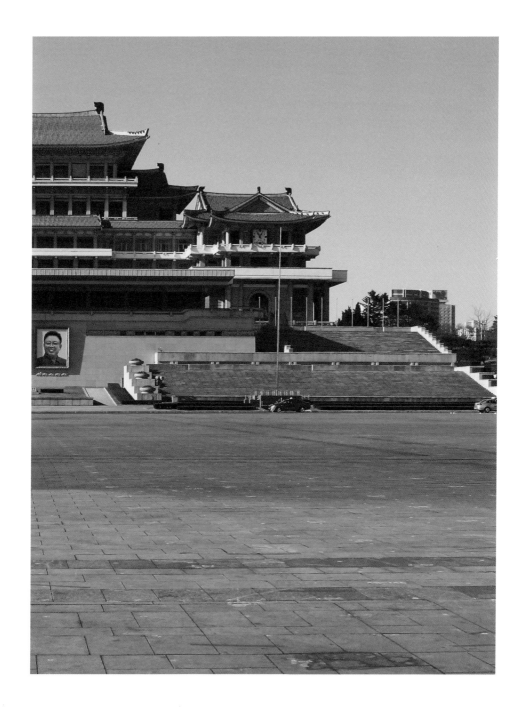

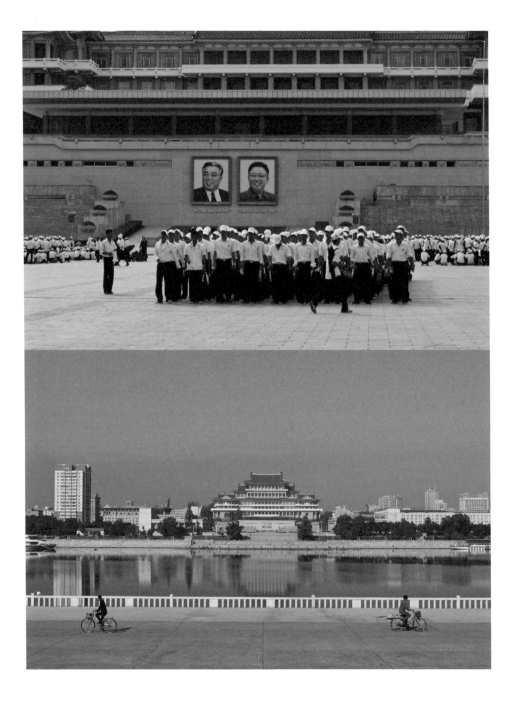

THE SQUARE

Two colossal portraits of Kim Il Sung and Kim Jong Il hung on the face of the Grand People's Study House overlooking Kim Il Sung Square. The ground was covered in painted dots and numbers, which were used as markers for the participants in Pyongyang's gigantic marches and rallies.

As I stood in the centre of the square for the first time, I tapped the dots with my shoes, wondering how many other feet had stood on that spot. Speakers and megaphones mounted on lampposts pointed towards the road which cut through the middle of the square, connecting one side of the city centre to the other. It was unnervingly quiet. An old bus trundled past, packed with tired commuters. A woman in a blue uniform and orange fluorescent jacket swept already-pristine pavement slabs. A few people walked by, but didn't stop to acknowledge the leaders' images.

A car horn blared and I jumped. I turned to see an ancient Lada appear to melt into the ground as it drove towards the far north-eastern corner of the square. At first I held back from going over to see where it had gone in case I was stopped by the police, but curiosity got the better of me and I turned and walked towards the opening. I passed between two bollards and saw the road descend into a tunnel. As I looked around, I noticed the same Lada reappear at the other side of the square. What was under there?

Nervously, I followed the road down. What had started off looking like a subway tunnel got darker and darker as the daylight slowly dwindled until I couldn't see a thing. The sound of my footsteps bounced between the concrete walls. I kept walking, wary that at any moment someone might come running after me and tell me to leave. But no one came.

I turned on the torch on my phone. Suddenly, I could see the outline of

(*opposite top*) University students rehearse for one of the country's many parades. A Korean friend who took part in the parades complained about the intensity of rehearsals, which for her district were held every other day. She insisted that they took part on a voluntary basis. — Pyongyang, August 2018

(*opposite bottom*) Kim Il Sung Square as seen from across the Taedong River. In front of the square is a series of steps which lead down to a stone platform where there are numbers painted on the ground. Men and their grandchildren gathered there in summer for fishing competitions, and crowds congregated on the bridges to cheer them on. — Pyongyang, October 2018

someone in front of me. It was an old woman, perhaps in her late seventies, standing in tattered plimsolls and headscarf by the side of the road. In front of her was a small wooden stool on which was a red plastic tray of wrinkly oranges. As I walked towards her she lowered her head and avoided my eye.

I couldn't imagine that she would sell much down here – there was nobody else around. I wanted to talk to her or at least buy something from her, but I didn't want to put her in a compromising position if someone caught her talking to me. So I walked silently past her.

I calculated that I must now be directly under the centre of the square, and imagined how deafening it would be down here when the infamous transporter-erector-launchers carrying the intercontinental ballistic missiles were chuntering along above ground, or what it would be like to stand beneath 100,000 marching soldiers. The thought made me wonder nervously if I was walking into some kind of military base or storage facility for the parades.

There were footsteps in the dark ahead and the faint sound of voices. Through the gloom, I could just make out a building fronted by two huge windows and between them double doors. I looked around me. No one. I had to see what was inside.

Hesitantly, my palms sweating, I pushed open the doors.

A young girl greeted me in Korean, smiled meekly and invited me in with an open palm. There were no soldiers, no weaponry, no military presence of any kind. It was an underground department store.

The air was thick and muggy and smelled of old food. There was obviously no ventilation down here. The lights were dim – single bulbs desperately trying to light the vast space. Jars of food, washing machines, children's bicycles and other goods were all on display. Bottles of beer with faded labels looked like they had been there for years. Kitsch porcelain animals propped up dated paintings of tigers and forest scenes.

The room echoed with the sound of the rickety wheels of red shopping trolleys being pushed across the dusty floors and the chit-chat of excitable customers. I couldn't believe it. Why would they build a department store here, of all places? It was just so odd.

Before long, the heaviness of the stale air defeated my curiosity, and I stood in the darkness once again with nothing but my disbelief.

The next time I saw footage of Kim Jong Un receiving the salute and admiring his arsenal of ballistic weapons parading around Kim Il Sung Square, I would remind myself there was a local version of Aldi not far beneath him.

Numbers and dots marked along the concrete of the square indicate to performers where to dance and stand. For rehearsals, the speakers which surround the giant space blasted music and the voice of a director who shouted counts to keep everyone in time. — Pyongyang, October 2018

(*following pages*) Sungri Street cuts directly through Kim Il Sung Square and in front of the Grand People's Study House. Many beer houses and shops lined the road but, in the plummeting temperatures of winter, most shops and bars were empty. The smell of sweet, glazed roast ducks seeped through windows and doors and out into the streets from the roasting ovens nestled inside most shops' entryways. — Pyongyang, January 2019

Soldiers and officials assemble to patrol the roads where crowds are gathering to watch the Independence Day parade marking seventy years since the establishment of North Korea. Even these soldiers were the centre of attention with children frequently waving their flags and shouting messages of support to them. The man on the right became very taken with the brass band playing nearby, frequently singing along to the military tunes with other spectators. — Pyongyang, September 2018

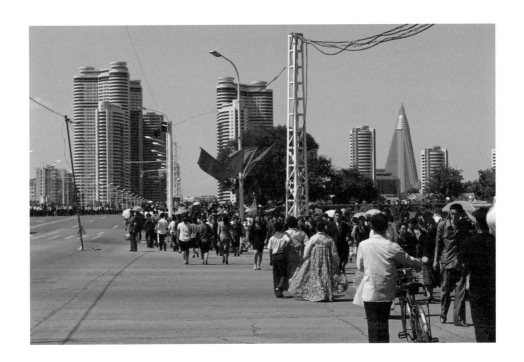

Large poles can be seen propping up the electricity lines used by Pyongyang's trolley buses to ensure tanks and other large military vehicles can safely travel along the streets from Kim Il Sung Square. No traffic was allowed through these roads apart from official vehicles, which roared down the empty streets. It was hard not to be caught up in the joyful atmosphere. — Pyongyang, September 2018

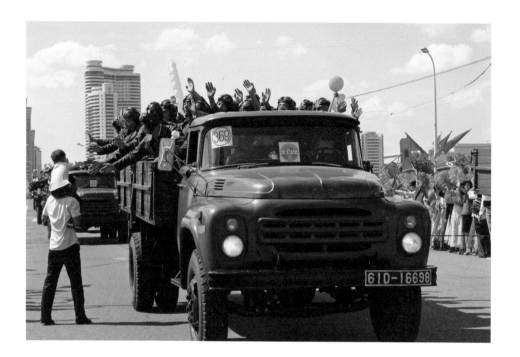

A child sits on his father's shoulders to high-five groups of passing soldiers. Entire families dashed across the road between trucks and tanks to get a better view and the chance of a fist bump. Two boys standing in the group to the left of this shot kept talking about which unit they'd rather be in. — Pyongyang, September 2018

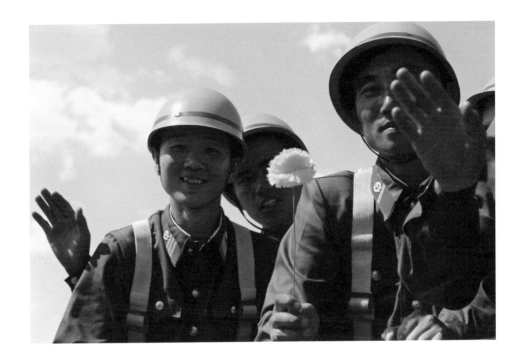

A young soldier smiles for a photograph while his comrades collect flowers and balloons from the cheering crowd. Many shouted, flirtatiously saluted and winked as they passed.
— Pyongyang, September 2018

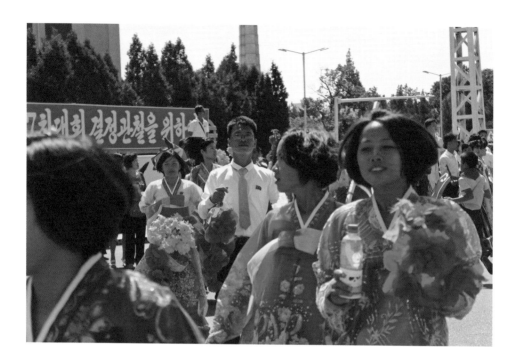

A young man crosses the street to get a better view of the passing trucks and tanks, surrounded by girls wearing traditional Korean dresses. A female English student who was standing next to me asked how I was enjoying the parade. Before long, between cheering and singing, she started telling me how much she enjoyed the Harry Potter series and reeled off her favourite characters, shouting to be heard over the passing tanks. — Pyongyang, September 2018

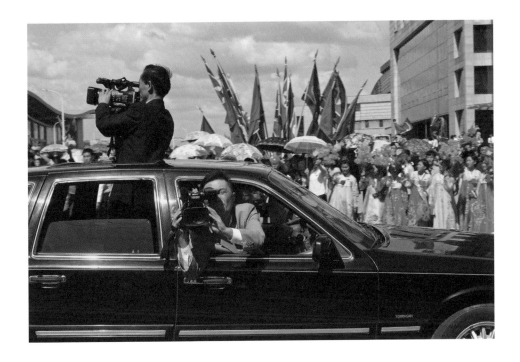

North Korean state TV cameras film the crowds, with particular interest shown for the attending foreigners. It wasn't uncommon for members of the foreign community to spot themselves on North Korean television: the presence of foreigners seemed to lend extra legitimacy to official occasions. — Pyongyang, September 2018

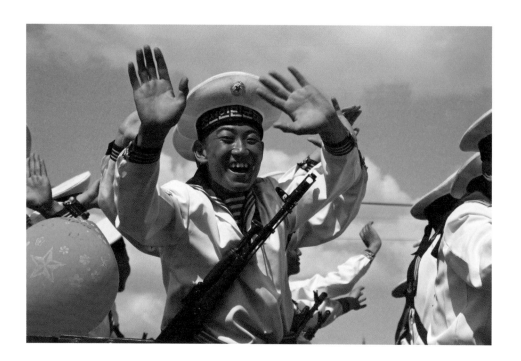

A young North Korean sailor in his summer uniform waves to the crowd. — Pyongyang, September 2018

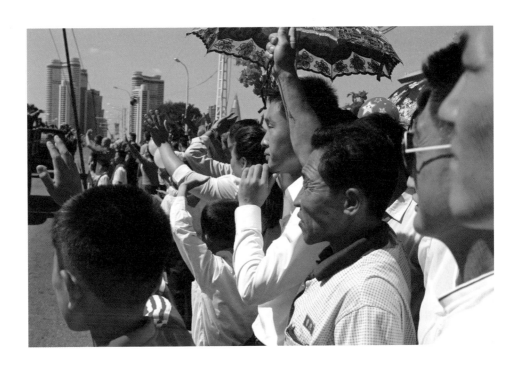

The enthusiastic crowds pushed tightly together, creeping closer and closer to the passing vehicles before a guard warned everyone to get back. Nearby stalls selling coffee and ice cream did a roaring trade all day. — Pyongyang, September 2018

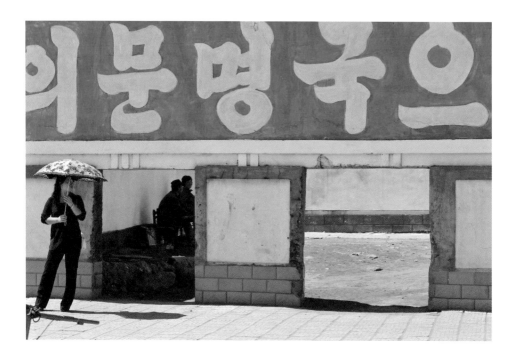

A woman stands under a hand-painted propaganda sign on one of Nampo's many dusty streets. The usual snack stands and coffee stalls seen in Pyongyang lined the roads of Nampo too, but the squatter apartment blocks looked tired and dirty. In Nampo there were fewer cars on the road. The battery-powered bicycles seen in Pyongyang didn't seem to have made it to Nampo yet. People rode their battered bicycles, ringing their bells at anyone in their way. The city was a cacophony of seagulls, bicycle bells, and people shouting to each other. — Nampo, September 2018

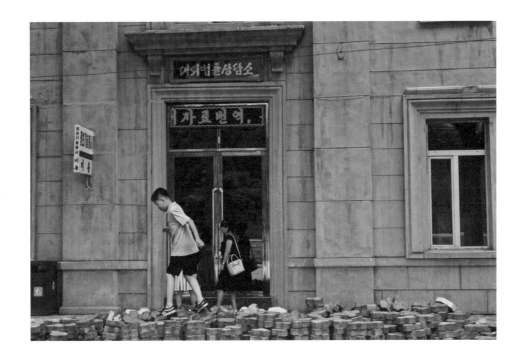

A boy jumps across piles of bricks waiting to be relaid outside a clinic in Pyongyang. During winter, a beggar woman frequently sat on the step of this doorway, quietly asking passers-by for money. Such people are rare in Pyongyang. The regime denies begging exists. — Pyongyang, August 2019

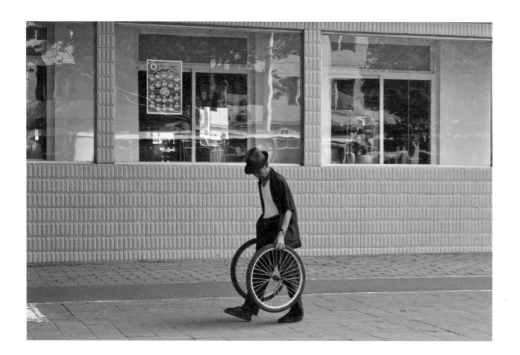

A reliable way for Koreans to supplement their income is by offering services to others such as bicycle or clothing repairs. Enterprising Koreans offered these services to foreigners, discreetly charging in foreign currency. — Pyongyang, August 2019

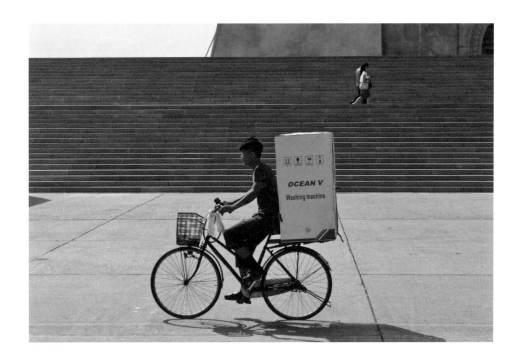

In front of the Juche Tower, a young man cycles home with a new washing machine, a luxury item for many Pyongyangers. Many electrical items in North Korea were made by recognisable brands; most were sold with the labels removed and replaced with North Korean ones. — Pyongyang, August 2019

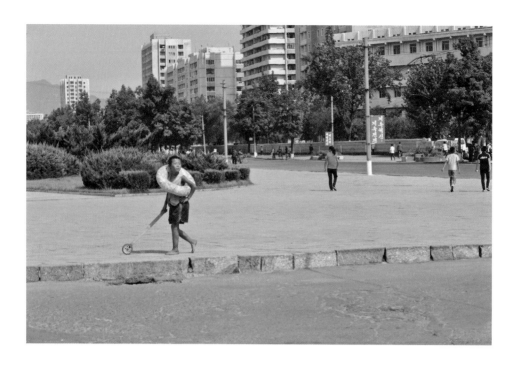

Many buses ran between Pyongyang and Nampo, crammed with families and children's colourful swim-rings and other paraphernalia for the beach. This boy spent about five minutes staring at a shop window display that showed the latest swimwear before heading off along the hot, cracked streets, salty seawater still dripping from his sodden shorts. — Nampo, August 2019

Just as anywhere else in the world, walking with colleagues is an opportunity to catch up on gossip about whose boss has ignored them again or whose work colleague is 'going to get it', as one woman said angrily as she passed by. I only caught the tail end of one woman complaining about her 'lazy' husband. — Pyongyang, August 2019

Basketball is a popular sport in North Korea, along with volleyball and football. On Pyongyang's many public pitches and basketball courts, passers-by often stopped to watch the games and cheer along, especially if they knew someone playing. On one occasion, a woman became so enthusiastic about a goal that she leapt in applause, catapulting a bag of apples into the air. Between fits of laughter, she chased after the apples, which were all rolling in different directions. When she caught the last one, the assembled crowd threw their hands in the air and cheered, as if she had just scored a winning goal. — Pyongyang, August 2018

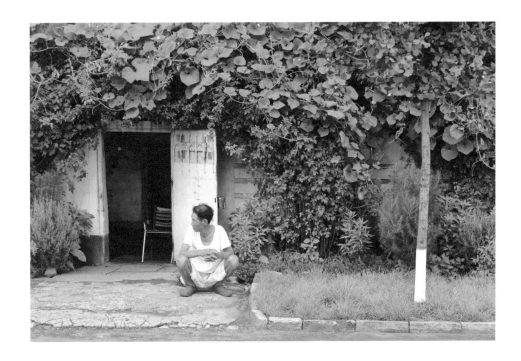

Eastern Pyongyang is among the poorest areas of the city, which also happens to be where most of the foreign community lives. Those living in close quarters could be heard throughout the long summer days shouting to each other from their front doors. Women often threw pegs to each other over their walls as they hung out their laundry. — Pyongyang, August 2019

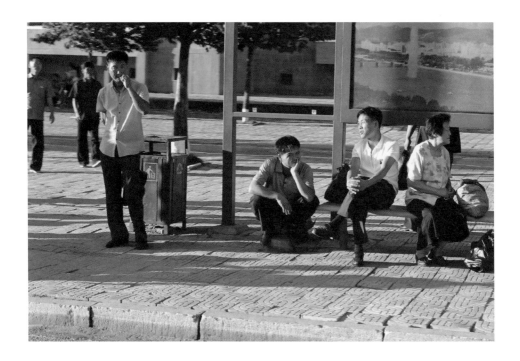

It was in ordinary moments like this that I wondered what Koreans spoke about in private and how much the regime featured in their conversations. Were they catching up on the football scores, the price of milk or discussing something else? It was impossible to know. — Pyongyang, September 2018

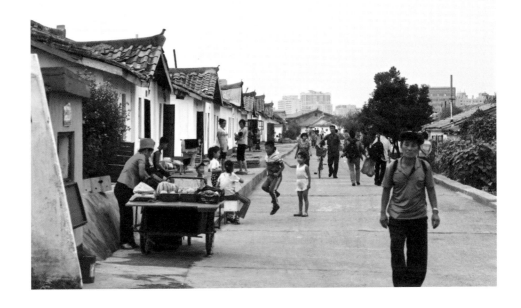

A typical scene along one of Pyongyang's streets. Nestled between the high-rise apart-ment blocks are the traditional North Korean 'harmonica houses', which the North Korean government is keen to get rid of. The smell of cooked Korean blood sausage from a nearby shop carried along this street, combining with the smell of kimchi being sold by the market-stall seller on the left of the photograph and petrol which was being used to polish the cars at the nearby garage. Children were shouting Korean songs and rhymes as they played with a skipping rope. — Pyongyang, August 2018

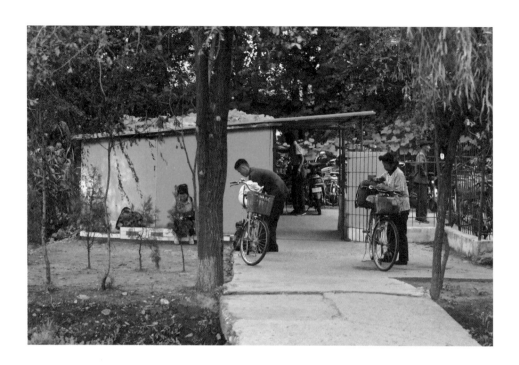

Even though bicycles were the most common way of getting around, they were rarely seen lying around or left outside buildings. This storage park provided riders with a safe place to keep their bicycles for the day. — Pyongyang, September 2018

When the summer sun starts to go down and the shadows of Pyongyang extend across the streets, the heat dissipates and the streets fill with people enjoying the cooler air. It was the perfect time to be outside. — Pyongyang, September 2018

Along one of Pyongyang's more dusty streets, two children played in the shade. They mockingly bowed to every passing car and truck, laughing and waving to everyone that passed. — Pyongyang, September 2018

Fishing is a popular pastime for North Korean men, particularly for those who are retired. From early in the morning, once the right spot is found, cigarettes, *soju* and the daily newspaper are passed around. Portable radios crackle with revolutionary tunes. Sometimes grandsons are brought along to learn how to cast a line. In summer, Koreans and foreigners alike enjoy hiring a small boat for the day and paddle along the water in the sunshine.— Pyongyang, September 2018

Lining the highway from Pyongyang to Nampo are small villages. Most homes lack basic amenities like running water, a constant electricity supply and sanitary facilities. Modern builds like this were increasingly visible on the outskirts of cities like Pyongyang but still a rarity in the deep countryside. — Youth Hero Highway, August 2018

Ryonggaksan, known in English as Dragon Mountain, is a spectacular location for hiking (although it is possible to drive the entire way to the top). Taken from one of the smaller peaks, here Pyongyang can be seen in the background behind a statue of cartoon characters. These statues were commonly seen in public parks and hiking trails. With its many picnicking spots on the way to the summit, Dragon Mountain was a beautiful place to spend a day away from the city. Tucked away at one particular picnic site was an older couple enjoying a barbecue, quietly cuddling each other in the shade while a family took wedding photographs among the trees. — Dragon Mountain, July 2017

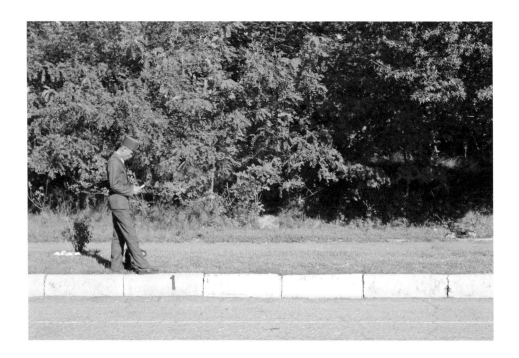

The highways surrounding Pyongyang were always scattered with hitchhiking Koreans. Trucks and lorries were flagged down at the side of the street and passengers jumped in or out, sometimes handing money or cigarettes to the driver. Even when seeing a foreign car, many still stuck out their hand hoping for a lift. This soldier, however, was rather embarrassed not to have recognised the foreign numberplate. I never stopped to offer a lift. If I had, I doubt the hitchhiker would have taken up the offer. — Youth Hero Highway, September 2018

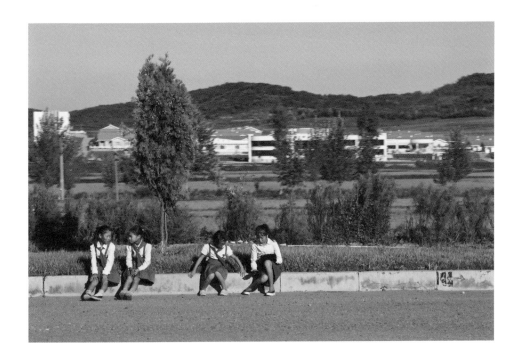

Many of North Korea's rural villages are miles away from main roads and tucked behind mountains and trees. A Korean friend who grew up in the countryside spoke about how they preferred the countryside to the city, especially as a child, speaking fondly of playing in forests, making fires and stealing their father's cigarettes so they could stash one down their sock to scare off any forest snakes. — Youth Hero Highway, September 2018

It was a rare opportunity for a foreigner to get this close to a North Korean rural house; however, before the renovation of Pyongyang golf course in 2018, the main road from the highway to the golf course ran through a local village. It took us within yards of local houses and groups of bemused children and farmers, until the entrance to the golf course appeared. As was the case with most patches of land in Pyongyang and the countryside, every inch of space was used for planting vegetables, which could be sold or eaten as seen here from the cabbages and corn growing in the front garden.
— Unknown village, August 2018

On the road to the golf course, the dirt roads started to become lined with tarmac: a sign that the destination was close by. The rustling stalks of corn lining the road provided shelter for the napping workers who rested in makeshift huts, allowing them to keep watch over the fields. — Unknown village, August 2018

(*following pages*) Some young boys walk home with their goats, which had been likely grazing on the nearby golf course. I met several farmers who came running onto the course chasing their herd, trying to dissuade their goats from munching the grass on the putting green. Many of them enjoyed taking photographs and posing with golf clubs as if they were playing themselves. — Unknown village, August 2018

THE ROAD TO CHINA

For miles, there were men, women and children lining each side of the dry, scarred road. Everyone had a spade and stood next to a small pile of dirt, their one job to throw as much as they could onto the road. Some workers walked up and down the line throwing containers of water over the dirt to dampen the dust so it could be pressed down by the oncoming vehicles. It didn't make any difference: the ground dried in seconds and the dust flew up again into the wind. It stuck to the sweat running down the workers' leathery faces. Occasionally they would cover the eyes and mouths of the younger child labourers with their sodden shirts, a kind offer of protection under the cruel, heartless sun. Nobody deserved this.

Several men hacked into a small hillside nearby. They loaded an ox cart with more dirt and sent the cart off to restock the mounds. The men worked shirtless, ribs protruding from their fragile bodies. Nobody spoke a word. I kept slowing down the car to navigate the huge potholes and, as the tyres crunched over the gravel, the workers looked up. The endless passing line of staring eyes pounded into my chest like thrown rocks, churning up overwhelming sadness and anger. I stewed in the embarrassment of my privilege: my clothes, my boxes for bringing back food from China, the shiny car.

Ahead, a woman with a sack of dirt on her back was making her way slowly across the road, and I stopped the car to let her pass. She dragged herself and the sack towards the other side of the road, raised her head painfully and looked at me. Her wrinkled, gaunt face was topped by hair that was matted and caked with dust, and I thought I could make out a graze and some blood on her head. Her eyes were hollowed, devoid of feeling. She looked broken. Her abused body was the only lasting reminder of who she was. The woman, with no show of emotion, simply turned, dropped her eyes back to the ground and kept walking.

The idea that life in the northern reaches of the country was worse even than this was unbearable. For seventy years the regime has claimed to protect its people, to care for them, to love them. Knowing that so much suffering went on beyond what I could see haunted me every day. It still does.

(*opposite*) While some cars travelled along these highways, for the most part it was heavy lorries and trucks that used them, most probably taking goods back and forth to China. Visibility was poor in the summer rains, and vehicles could often be seen crashed into muddy verges having slid off the road. — Unknown location, May 2018

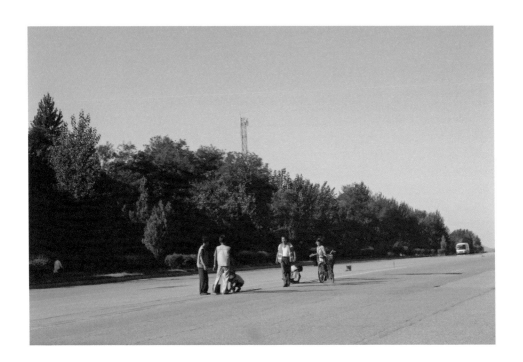

With little equipment to maintain roads properly, teams of men were left to repair roads with what they had. To the left beside the trees was a rusty metal bin, inside which was a smoking fire. The flames licked at a metal pot which was balanced on the top, inside which was hot, melted tar. The men walked to the bin with a spade, loaded it with the stinking liquid and carried it back to the cracks. — Youth Hero Highway, September 2018

The main routes out of Pyongyang are wide. They would easily fit six lanes of traffic, if the lanes were marked and had enough traffic to use them. Vehicles ignored the yellow dividing line and swerved and twisted over the treacherously bumpy concrete at high speeds, avoiding as many holes as possible. It is well known that these wide roads could also serve as runways in a time of war. — Youth Hero Highway, September 2018

(*following pages*) Soldier-labourers take a break while relaying huge sections of the road from Pyongyang. The Youth Hero Highway is the main road between Pyongyang and Nampo. — Youth Hero Highway, September 2018

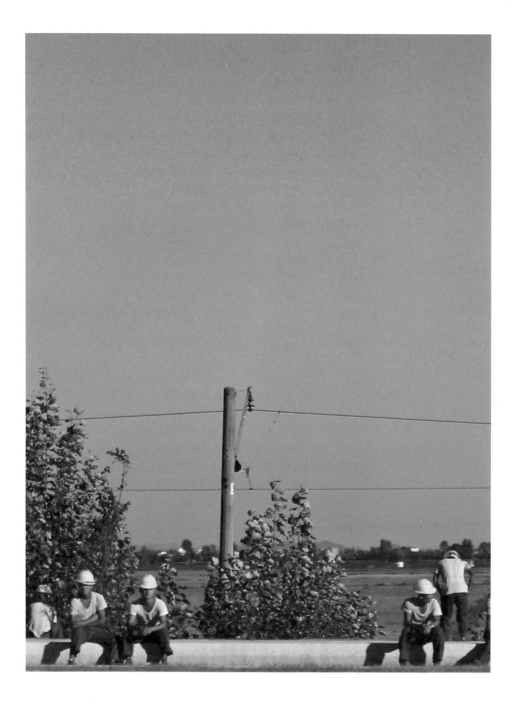

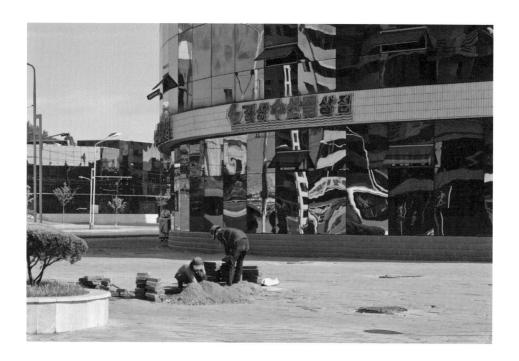

In Mansudae, one of Pyongyang's most exclusive areas, construction workers repair the pipework beneath the pavements. Similar to Pyongyang's buildings, once the exterior is removed, the chaos of what lies underneath often tells a different story. — Pyongyang, August 2019

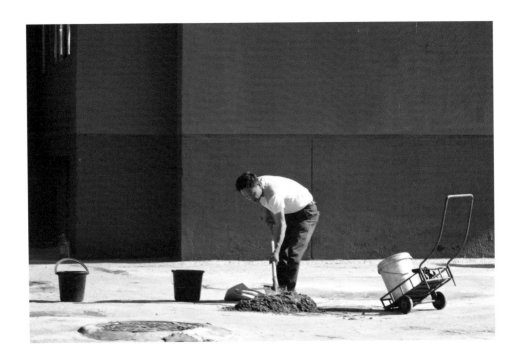

In anticipation of Chinese President Xi Jinping making the first state visit to Pyongyang in 14 years, construction work all over Pyongyang and the surrounding areas was increased. Buildings were repainted, new propaganda and lights were installed, pavements were repaired and houses were adorned with plants and flowers. This labourer was one of the thousands assigned to carry out this mammoth task. — Pyongyang, August 2019

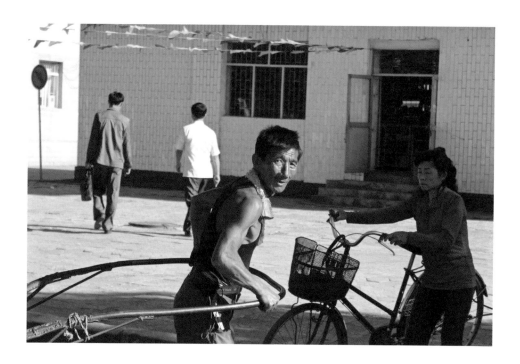

Life is hard for the sizeable portion of North Korea's population who are involved in backbreaking agricultural work, more often working land by ox and cart or by hand than with more suitable equipment. Blisteringly hot summers cause serious droughts, and severe winters further punish those who already live on very little. While the regime praises farmers for being heroes of self-sufficiency and driving the economy forward, the stark reality is one of extreme poverty and a battle for survival. — Nampo, September 2018

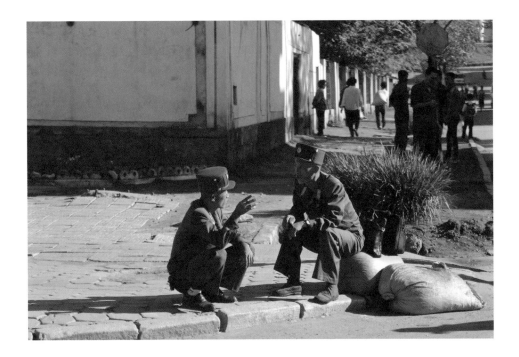

As these young soldiers smoked and talked together, passing girls under sequin-speckled parasols were examined by their wandering eyes. Before one girl was out of earshot, one soldier silently sketched the number '8' to the other, as his friend nodded in agreement. The men continued to mark each passing girl's attractiveness out of ten until they had run out of cigarettes. — Nampo, September 2018

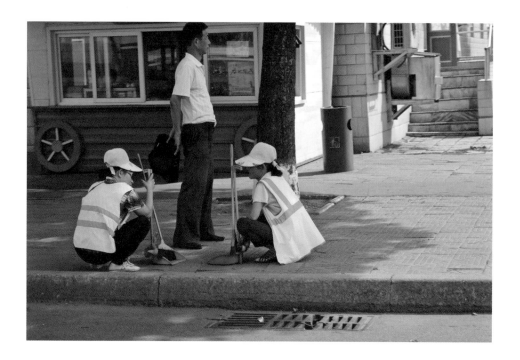

Labourers are often supervised by an onlooking superior, and it wasn't uncommon to see even those superiors also occasionally supervised. The chain of command and control stretches far and wide. However, a Korean friend told me that they were good at 'looking busy' if necessary. — Pyongyang, August 2019

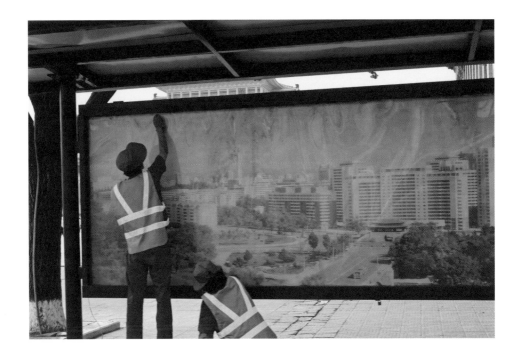

Two labourers put up a new poster for a bus stop in Kim Il Sung Square. The lack of advertising in Pyongyang was most noticeable to me at places like this, where images were mostly of other areas of the city or notable buildings or monuments. — Pyongyang, August 2018

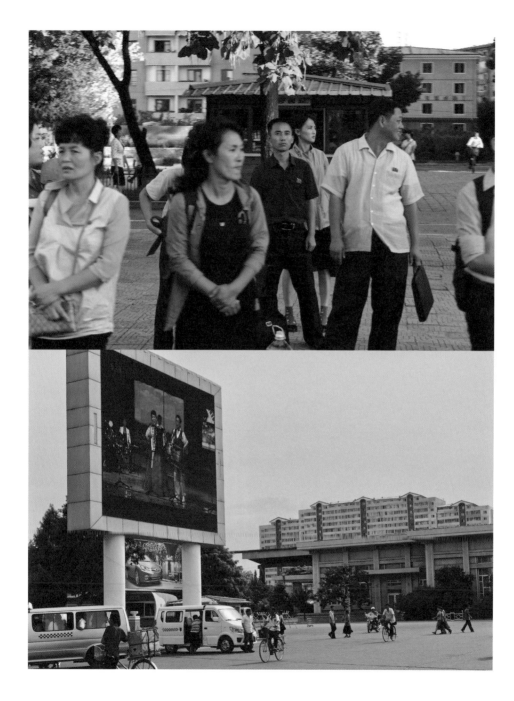

THE MISSILE

It was an early August morning, and slivers of watery sunlight glanced off the apartment blocks opposite. The birds were starting to sing, accompanied by a strange, dull hum in the distance. I threw off the bed covers and walked over to the window.

Then I heard it. A deep rumbling. It must be a storm? It wasn't thunder, more like a plane flying very low overhead – but the sound didn't fade away.

I bolted down the stairs and threw open the front door. The rumble was instantly much louder. I ran out onto the dewed, mulchy grass and looked up at the sky. The humid air of dawn pressed into my chest and I could feel my body shaking.

I couldn't see beyond the roofs of the surrounding buildings, but I could hear it: the worst kind of spectre. My phone started buzzing in my pocket with messages from other foreigners. They could see what was happening from their windows: it was a missile. As we would soon learn, North Korea had launched a Hwasong-12 ballistic missile from Pyongyang International Airport, sending it on a trajectory over Japan before it landed in the Pacific Ocean.

I stood in the middle of the damp garden, staring at the sky, listening to the rumbling until eventually it faded.

Within an hour I was driving out of our gate to see what was happening in the city. Were Koreans jumping up and down and clapping their hands in glee at this apparent show of force? I tuned the radio to hear the morning news reports to see if I could pick up any familiar words suggesting an announcement of the launch, then took a deep breath, bracing myself for what I might see, and turned onto the main road.

The streets were bustling as usual with commuters making their way to work. I passed the big TV screens where important announcements were usually broadcast: nothing. The news came on: nothing. I looked at the face of every pedestrian that crossed in front of the car and quickly concluded that they probably had no idea what had happened. It felt completely normal.

While the world around us was talking about what a war with North Korea might look like, Pyongyang wasn't listening. We were in the eye of the storm.

(*opposite top*) Waiting to cross the street in Pyongyang. — September 2018

(*opposite bottom*) A large screen outside Pyongyang train station. — July 2018

Korean chess (or *changgi*) is a popular pastime for men all over North Korea. Many public parks and green areas had stone tables that were packed with players and spectators in summer. — Pyongyang, August 2019

In Pyongyang, board games attracted large crowds, especially on a Sunday. Many gathered to cheer on their favourite players or place a bet on who they thought would win. Young students could also be seen sitting at the tables, taking on older and tougher players to improve their games. — Pyongyang, August 2019

(*following pages*) Women repaint the balconies of an unfinished block of flats in Nampo. It was common for residents to move into buildings before they were finished being built. Among the grey concrete walls, laundry could be seen strung up between dusty pillars and the aroma of spicy broths could be smelled from the street, pouring out of the gaps where the windows were yet to be installed. — Nampo, August 2019

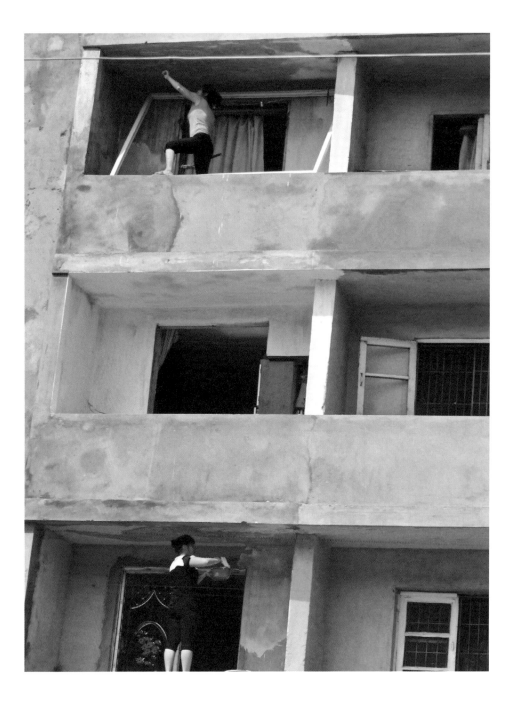

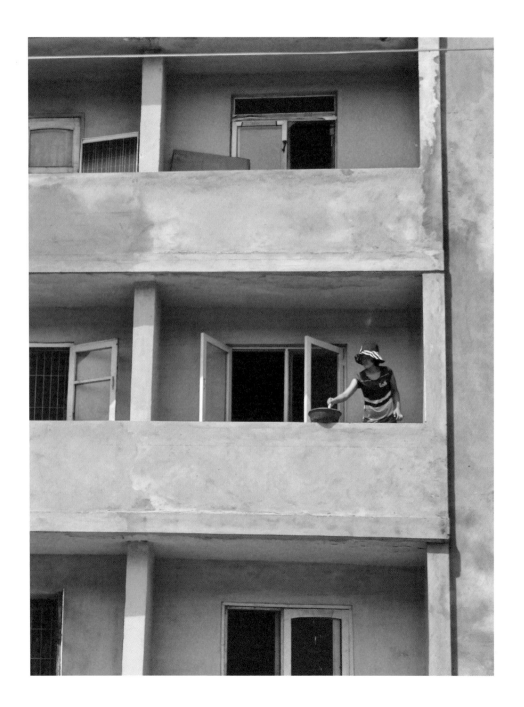

The *Rodong Sinmun*, North Korea's daily newspaper, is displayed in cases all over the city for the public to read. During the warming of relations between North and South Korea in 2018, and the 2018 Singapore Summit with US President Donald Trump, these newspapers drew noticeably more groups of people than usual. To the left of the photo is a bookstall which stocked comic books, posters, novels and notebooks. I managed to buy a red notebook with a propaganda slogan on the front, but my choice was immediately narrowed down by the seller, who told me I wasn't allowed to buy anything that displayed the names of the leaders. — Pyongyang, October 2018

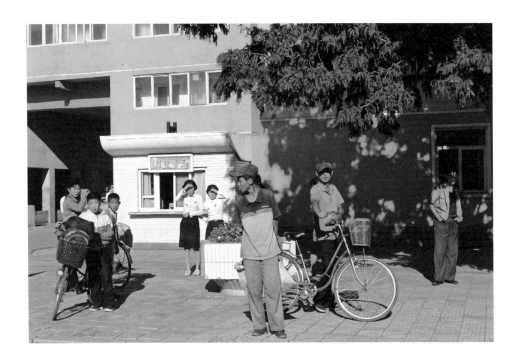

A typical street scene in Nampo. Further along the same road I saw a soldier trying to wrestle a bicycle off an old woman. She screamed at the young soldier as she heaved the handlebars back towards her. Nobody stopped to help. — Nampo, September 2018

I saw this man every day I was out walking around Pyongyang. Every day he sat in the same spot, smiled and nodded his head as I passed, before returning to his cigarette. Everyone who passed by seemed to know him. — Pyongyang, August 2019

At the hardware stalls in Tonghil Market, Pyongyang's largest indoor market, men regularly crowded around the sellers to fill their small leather cases with odd screws, hinges or tools. Nothing went to waste. If something was thrown out in Pyongyang (by the foreign community), you knew that every piece of it would be reused and recycled by whoever collected it. — Pyongyang, August 2019

Beyond the lanes and alleyways connecting many of Pyongyang's residential areas, small courtyards are the heart of communal living areas. After wandering into one on a summer's afternoon, I met two young sisters who were cuddling a golden pure-bred English cocker spaniel puppy. They had named him Yang Yang and were teaching him how to sit. They warned me never to feed a dog meat otherwise the dog would learn to bite. A man who was at a table, smoking and reading a newspaper, got up, smiled, and warmly but firmly escorted me away. — Pyongyang, September 2018

Close to Pyongyang's Koryo Hotel, men wrestle a rickety platform into place for repainting work. They shouted and struggled as they grasped the ropes, with one of them jumping on as it started to ascend. Shortly afterwards, another man appeared with several tables of all different sizes. He stacked them one on top of each other and carefully climbed up them to wash the shop sign. When I gestured that he should be careful he nodded his head and gave a big thumbs up. — Pyongyang, August 2018

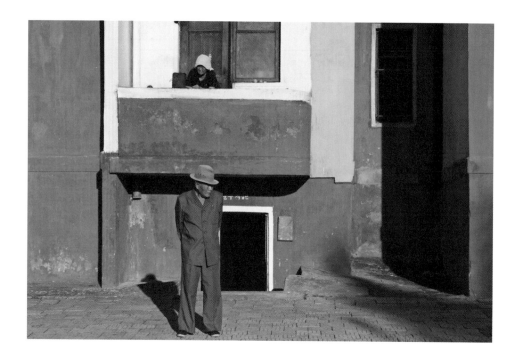

I often wondered what the older generation of Koreans experienced through their lives. They must have seen so much in their lifetime. Had they lived through the war? What did they think of their country limping onwards through history? The so-called Arduous March famine in the 1990s had left no one untouched. Had they lost family members or friends to starvation? In 2018, when their young marshal embraced the South Korean president and stepped across the demarcation line into South Korea, did they wonder if they would live to see the two Koreas unite? — Pyongyang, September 2018

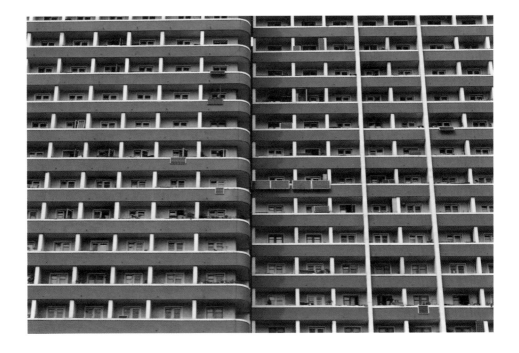

Ground-floor apartments are most favoured in North Korea. Despite top-floor apartments having views, unreliable electricity supplies mean that elevators are often unusable and residents have to instead climb countless flights of stairs. While it was impossible to see the inside of people's houses during the daytime, when the lights were lit at night it was possible to see a glimpse through the usually darkened windows. Gaudy curtains, pictures and lamps decorated many living rooms and, of course, two gilded portraits of the Kims were on every apartment's wall. — Pyongyang, October 2018

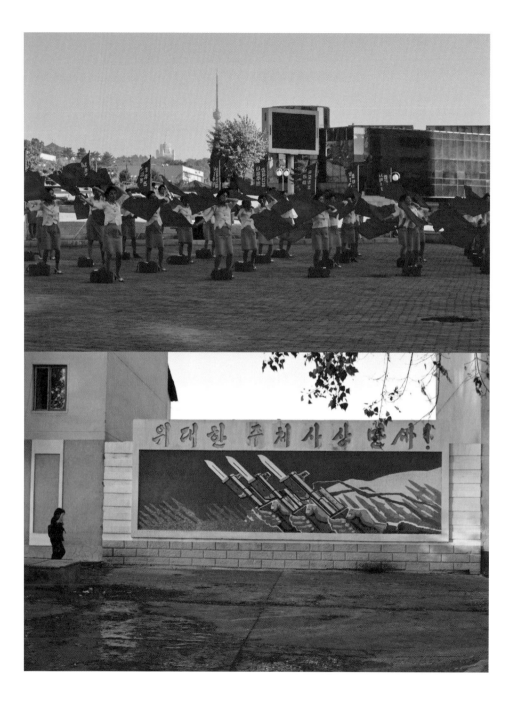

THE RALLY

As I opened the car door, the dull clamour I'd heard from my apartment became a thunderous wall of noise of stamping feet and chanting voices. I felt the hair on the back of my neck stand on end.

As I hurried around the corner, in front of me appeared hundreds of university students carrying gigantic banners and North Korean flags, the bright white fringe of the flags reflecting dazzlingly in their mirror-polished shoes. Every student, male and female, looked stern and decisive as they marched through a funnel of soldiers, who created a pathway from the square to the nearby Department Store No. 1 car park, which had now become a meeting point. Every flag bearer marched perfectly in time to the loud music blasting from the loudspeakers behind the store. The soldiers looked fixedly ahead.

When I got past the store, I was quickly engulfed by the horde of students and other young people making their way to the square. Soon I was prevented from going any further but could peer fifty yards ahead to the northern edge of the square. Tens of thousands of people were holding up their right fists, standing in perfectly parallel lines, chanting in priestly unison and punching the air. I could feel the vibration from the crowd's roar tear through my body, the sound of their stamping feet knocked the breath from my lungs.

Those at the back of the crowd were standing on children's plastic stools, eyes fixed on the Grand People's Study House at the end of the square, straining to hear the voice belting from crackling speakers. Rows and rows of senior military and Party officials were in the seating areas on either side of the giant

(*opposite top*) Housewives from each district in Pyongyang gather to sing, dance and encourage passing commuters as they make their way to work. The women made their own costumes and had different outfits depending on the season. Many groups also played drums, which can be seen on the ground in this photograph. These women also made regular appearances at the many parades. I never knew if participation in these morning displays was obligatory. — Pyongyang, August 2018

(*opposite bottom*) A propaganda sign displays a slogan about the greatness of 'Juche', North Korea's enigmatic national political ideology of self-reliance and independence. I always found this area very strange in that it was very run down and dirty but signs such as this were always kept so pristine. Passers-by regularly stopped to brush any dirt off the wall or sweep the ground in front. — Pyongyang, September 2018

portraits, facing the crowd and joining the rehearsed chanting, some until they were red in the face, their shiny medals glinting in the sun.

After only a few months in Pyongyang, I still didn't know enough Korean to understand what the speaker was saying, but I later learned that the rally was North Korea's response to the economic sanctions agreed at the UN Security Council in the wake of the July 2017 missile tests. As I looked at the faces of the people in the crowd, I longed to know how many of them really cared about nuclear weapons, sanctions, the UN . . .? How many of them really saw the US as their enemy? Did any of them suspect that their own leadership had caused the crisis they were facing?

Suddenly the shrill, staccato voice issuing from the speakers stopped, and the crowd erupted in applause. Within seconds the multitudes had parted and had started to spill from the square out into the roads of the city, as if a starting gun had been fired at the beginning of a marathon. I sheltered behind a barrier above the entrance to an underpass to shield myself from the oncoming tsunami of people that washed around me: giggling teenage girls ran arm in arm with friends, blowing the hair from their eyes and clopping their heels on the uneven pavement; young men in jaunty caps swigged from cans of beer and laughed boisterously; people teased each other and laughed hysterically as they struggled to overtake the masses in front of them. Shoes flew off, babies rode on parents' shoulders, queues grew at the coffee stands. Elderly men smiled at me as they passed, Millennials pointed at my shoes and sheepishly practised their English. A couple zoomed past on a bicycle, the boy pedalling furiously, the girl glued to her smartphone. This wasn't an angry crowd marching on a city – it was a race to get to the front of the bus queue.

It didn't take long for the crowd to disperse completely. Standing in an empty Kim Il Sung Square, I tried to make sense of the metamorphosis I'd just witnessed. A solitary cleaner swept the concrete slabs with her broom and long-handled dustpan, practically brushing around my feet as I stared at the giant portraits of the dead leaders. It looked and felt as if nothing had ever happened.

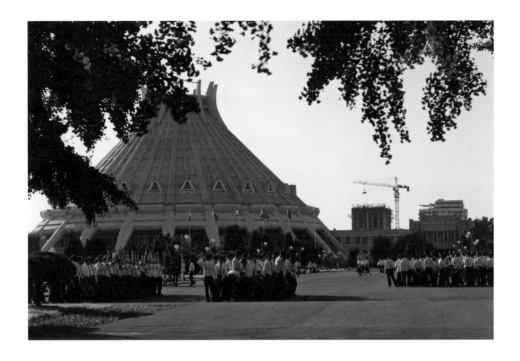

Pyongyang is famous for strangely designed buildings such as this ice rink in the Potonggang district. The vast car parks and public areas surrounding these buildings doubled up as rehearsal areas when scheduled parades and rallies were approaching. Groups of students, work units and even soldiers made best use of these open spaces. Soldiers practised their marching while holding fake 'drill-only' weapons. — Pyongyang, September 2018

(*above*) The desolate North Korean theme park is often used in the West to portray a somewhat cartoonish and simplistic picture of the country. There were plenty of summer days when I visited theme parks full of families having fun, but the bleakness often portrayed by images of empty roller coasters and rusty rides seems to fit more neatly with popular consciousness. The reality behind empty parks such as this one was that parks were closed in winter as it was too cold for most outdoor activities. As for summer, parks were opened only when work units, residential groups or party committees had organised in advance to attend. — Pyongyang, January 2019

(*opposite*) The Ryugyong Hotel, an unfinished hotel that dominates Pyongyang's skyline, is the tallest unoccupied building in the world. During the warming of relations between the two Koreas in 2018, the hotel started being used as a projection screen for a nightly light display showing a fluttering North Korean flag, and propaganda slogans moving across the pinnacle. Security officials were always very quick to dissuade foreigners from taking photographs. — Pyongyang, August 2018

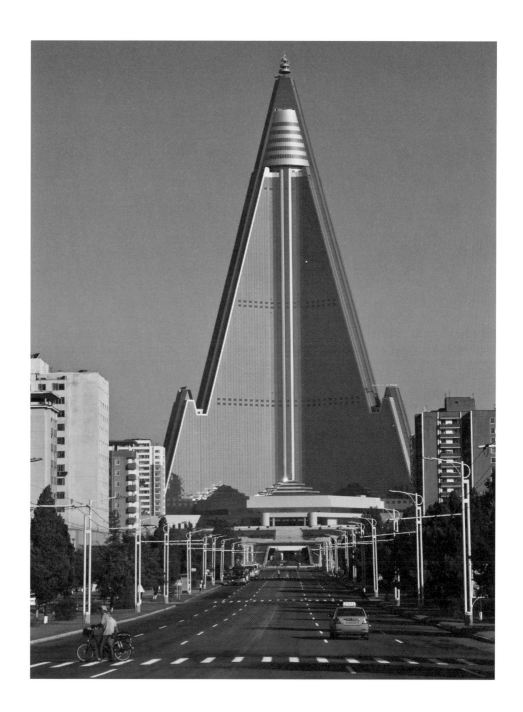

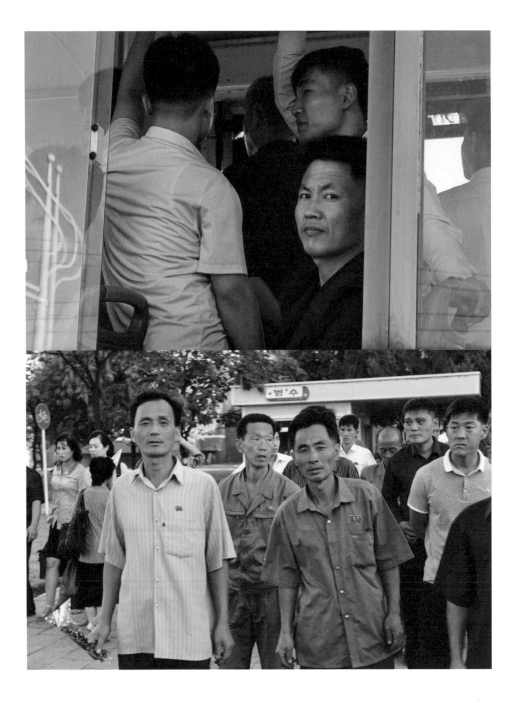

THE SHOOTING RANGE

There were a couple of men in the shooting booths. They had taken off their khaki jackets, revealing white vests, and were waiting for their assigned female assistant to present them with their chosen weapons. They both sucked on their cigarettes as they watched the girls polish the barrels. A selection of guns were laid out on a table. Brand-new ear protectors were also on display, although no one seemed required to wear them.

I sat in the viewing area and looked up at the three televisions that hung from the ceiling, each showing close-ups of the targets. I asked one of the assistants how much the North Korean version of an AK-47 cost to fire.

'One dollar per bullet,' she said. She pointed to the men, who were both being handed the AK-47s. They posed with their weapons, cigarettes dangling from their mouths. One of them leaned forward and whispered something into the ear of one of the girls. He smelled her hair as he stood back. The girl just indicated towards the booths with a deadpan expression.

The men took their places and aimed towards six metal cages stacked on top of each other, about twenty metres away. Inside the cages, happily minding their own business, were several young pheasants.

A couple sat down behind me in the viewing area. They had drinks and snacks, and their eyes were glued to the screen. At every shot the couple cheered, shouted or groaned. In a matter of minutes, a crowd had appeared.

Clack! One of the pheasants started to limp. The audience cheered.

Clack! A loud squawk – the audience were on their feet.

After several rounds, the men turned and bowed theatrically to their applauding audience.

I watched the men pay with a hundred-dollar bill at the till. Suddenly, an old man appeared. Dangling from his hand were two shot birds, still moving. The men noticed me staring. They pointed to me, smiled, bowed their heads and laughed. The old man took his cue and walked towards me, holding the birds out for me to take.

Later that day, I gave them to my friend Mrs Hyeong as a gift.

'Fresh?' she asked excitedly.

'Yes, Mrs Hyeong. Very fresh,' I said.

(*opposite*) Korean men make their way to work during the morning rush hour.
— Pyongyang, September 2018

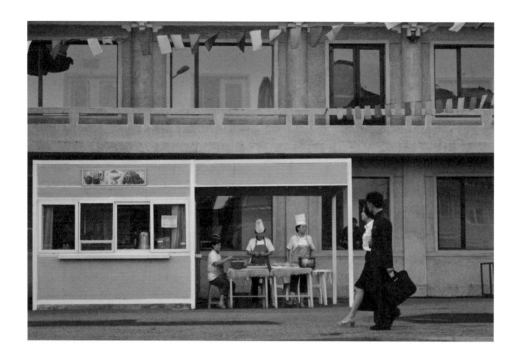

One of the many *bingsu* (a sweet iced snack) stalls which turn into steamed bun and coffee stalls in winter. These chefs were regularly giving samples to passing children, who were entranced by the sweet treats on offer. — Pyongyang, September 2018

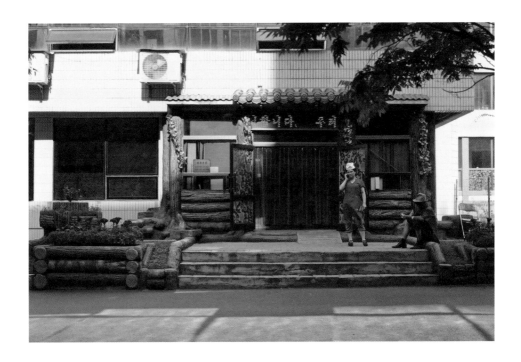

This restaurant was well known to the foreign community for its excellent Korean barbecue and green bean pancakes. During one visit with a friend, I noticed the music playing was a piano solo version of the *EastEnders* theme tune, followed by several George Michael hits. — Pyongyang, August 2018

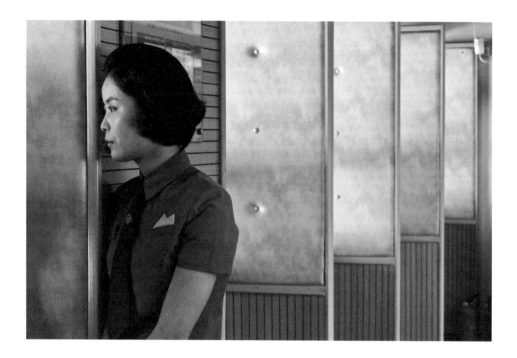

(*above*) A young assistant at the Pyongyang gun range looks on as customers fire at empty beer bottles and live animal targets. It was noticeable that virtually all waitresses, servers and shop assistants in North Korea, including the girls in the gun range, were young and beautiful women. Countless times I saw drunk Korean men head to a table of young, pretty girls in a restaurant and try to kiss them. The girls did nothing but giggle nervously and go along with it: there was no choice. The North Korean constitution explicitly states that women are respected in North Korean society, but much of what I saw didn't bear this out. — Pyongyang, August 2018

(*opposite*) During a guided visit to one of Pyongyang's food factories, foreign guests were shown into a dining room and presented with bread and snacks made on the premises. Finding good-quality bread in Pyongyang was difficult at the best of times, so most of the group were very excited to have finally found some of a high quality. However, on returning to the factory's shop in the weeks after the visit, the shop assistant denied that bread was ever there and the returning customers left disappointed. — Pyongyang, December 2017

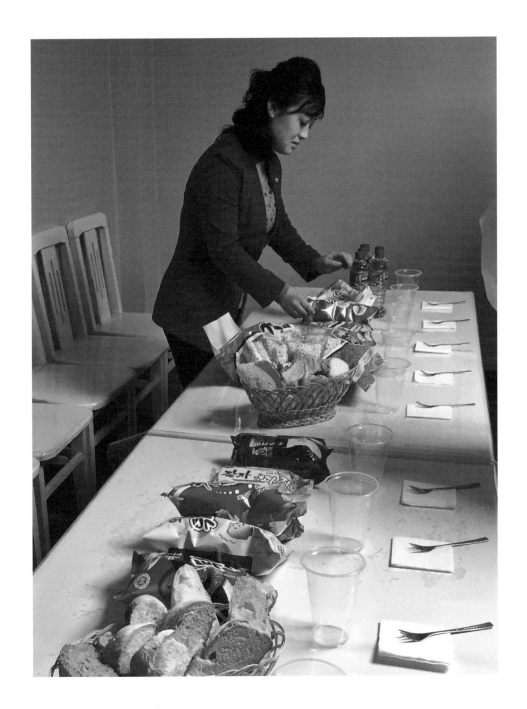

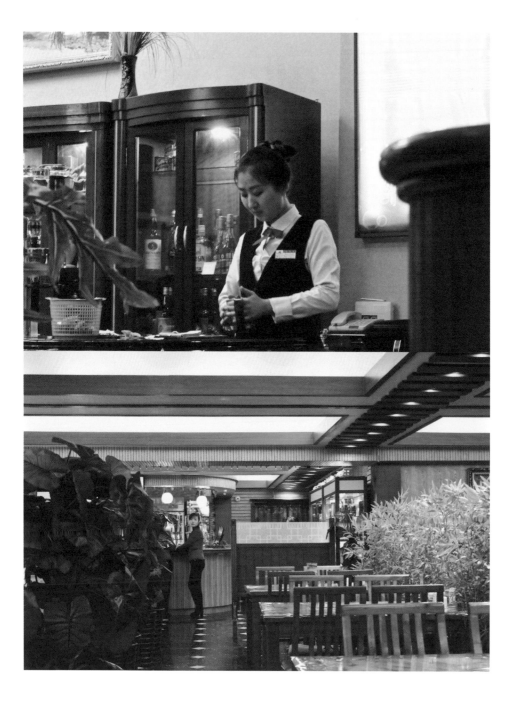

THE RESTAURANT

I stood outside a restaurant on the bottom floor of a large circular apartment block. As I walked up the steps and pushed the heavy plastic curtains aside I was oddly nervous. In the porch was a fridge full of cream, butter and cheese – all with Chinese labels – which was locked shut by two heavy-duty bicycle chains. A sign on the glass fridge displayed something Korean in bright red text, underlined and emphasised with three exclamation marks.

Pushing through the next heavy wooden door, I saw multicoloured fairy lights strung above huge display cases that boasted boxes of imported confectionery, bottles of Hennessy cognac and Johnnie Walker whisky priced at $100 per bottle, and a selection of old-fashioned porcelain farm animals. I could hear people laughing and clinking glasses; in the air, cigarette smoke mingled with barbeque fumes. On the long, polished reception desk was one hand-written bill and a giant blue calculator covered in Winnie-the-Pooh stickers. I waited a little nervously for a waitress to arrive.

A young girl popped her head round the kitchen door. As soon as she saw me her eyes bulged, she gasped and the door quickly closed. I heard her shouting for someone else. '*Han Dongji!*' she shouted over and over again. The foreigner had been spotted.

Another, slightly older woman opened the door and marched towards me. She smiled and indicated politely that I should go next door. I mimed that I wanted to eat there but she wasn't having it. The woman repeated herself and ushered me outside before locking the doors behind me.

I walked to the next entrance that I could find, which, oddly, was unmarked. Casting my suspicions aside, I pushed open the door to find myself standing in a dark, empty corridor. I turned my phone on for light and followed its beam up some dusty, grey steps. At the top of the stairs was a tired-looking Japanese-

(*opposite top*) A bar girl polishes glasses at the bar of the Koryo Hotel in Pyongyang. Bottles of Hennessy, Johnnie Walker and Chivas Regal were common luxury items on display in the cabinets of restaurants and bars. — Pyongyang, August 2019

(*opposite bottom*) This restaurant, close to Pyongyang train station, was one of many places that sells North Korean lottery tickets. A Korean friend said prizes were usually houseware and electrical items such as washing machines and fridges. Tickets were not available to foreigners. — Pyongyang, December 2018

style sliding door with small moth-holes in the paper panels. I could smell more cigarette smoke seeping from around its sides. Tentatively, I slid it open.

I was on the first level of the building. The restaurant's windows wrapped around the entire circumference of the apartment block. At every table groups of men in khaki trousers were shouting and laughing with each other, clinking glasses of *soju* and whisky. Their khaki shirts were draped over their chairs and the floor. Some had taken their shoes off, their toes showing through holes in discoloured socks. At a nearby table, five men were making their way through what looked like their second bottle of whisky. Tables were covered in plates of food with barely enough space for large tankards of beer. Young girls flitted past in glittery heels, smart pantsuits and air hostess-style hats. The men greedily eyed up the girls, some even trying to grab them as they walked past. The girls didn't do much other than exclaim and then carry on with what they were doing. A soldier in a stained white vest, khaki cap still on his head, drunkenly sang karaoke on a small stage surrounded by tall vases of garish artificial flowers, microphone in one hand and a glass of whisky in the other.

An older woman with greying hair and small round reading glasses appeared. She marched towards me, scowling, and waved her arms to usher me out of the room. She came threateningly close to me and I backed away. 'Closed!' she shouted over and over in English. But the restaurant clearly wasn't closed. Why was she lying when I could see that the place was open? I tried to smile and explain but she kept shouting at me: 'Closed! Closed! Closed!'

Before I knew it, she had slammed the panel shut. I could see her shadow in front of it, guarding the door in case I tried to come back in. I walked away feeling completely humiliated.

That was my first experience of being rejected simply because I was a foreigner. While many of my experiences with Koreans had been positive, I always had an uneasy sense that I was absolutely not welcome in their country. It made sense that the people wouldn't want me near them: if something went wrong and they said or did something they shouldn't, and they were being watched, who knew what the consequences would be? I had come to North Korea thinking there was a strict set of rules in place, and that it would be clear what was and wasn't tolerated. But, as I'd seen in so many ways, those rules were unclear and unpredictable. I became quickly exhausted by the constant psychological battle of how I fitted in to it all.

The Ansan sushi restaurant was one of many Japanese restaurants in Pyongyang serving sushi, ramen and other Japanese foods. Japanese food and goods are hugely popular among the Pyongyang elite. Many Korean friends were quick to point out how they favoured the quality of Japanese food and goods as opposed to Chinese items, which they described as bad and cheap. — Pyongyang, August 2019

This restaurant was one of several Italian restaurants in Pyongyang that served Italian food. Many of them had also started creating their own extensive cocktail menus and decorating their interiors with quirky chalkboards and shabby-chic furniture. Hugely popular with locals and tourists, this restaurant was one of the many where waitresses provided entertainment by singing and dancing for customers. Songs included Disney classics and pop ballads such as 'My Heart Will Go On'. — Pyongyang, August 2019

Tofu is a staple of the North Korean diet. A block of tofu at Tonghil Market cost around 1,000 won (at the time, roughly less than 10 cents). This dish of fried tofu served with *gochujang*, a spicy Korean chilli paste, is a popular dish, served on a sizzling hot plate.
— Pyongyang, August 2017

A man crosses the street in Nampo on a hot summer afternoon. Further along the road, I noticed several soldiers with armbands, stopping people and demanding what looked like ID cards. A well-dressed Korean man was pacing backwards and forwards, looking very distressed and shouting at a soldier who was examining his card. He kept gripping his head and running his fingers through his thick black hair. The soldier took out his mobile phone and held it to his ear. The man started walking in circles and rubbing his hands. I knew that what I was seeing was by no means the worst that happened in this country, but it didn't make it any less unnerving. — Nampo, September 2018

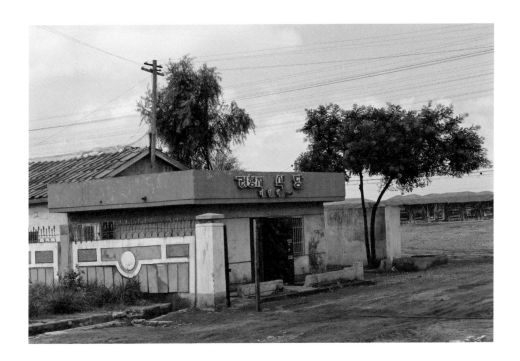

Small, stand-alone restaurants like these could still be seen in poorer areas of the city. Usually they would only have a few tables and chairs inside. Many of Pyongyang's newer restaurants were contained within shiny city-centre apartment blocks and were accustomed to foreigners. These smaller places were not, and we were often greeted by looks of shock and amazement upon entering. — Pyongyang, August 2019

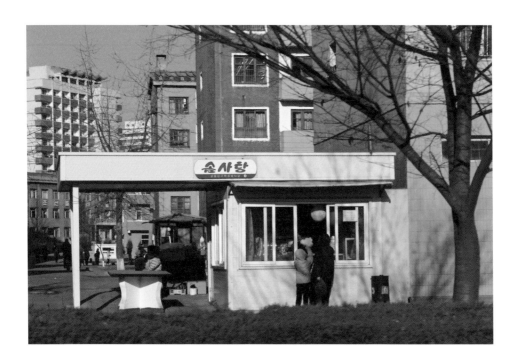

Queues gathered at food stalls in Pyongyang during winter to buy hot, sugary coffee or steamed buns. In summer 2019, many food stalls were converted into DVD shops, selling North Korean, and some Chinese and Russian, films for 5,000 won (at the time, roughly 40 cents) each. — Pyongyang, December 2018

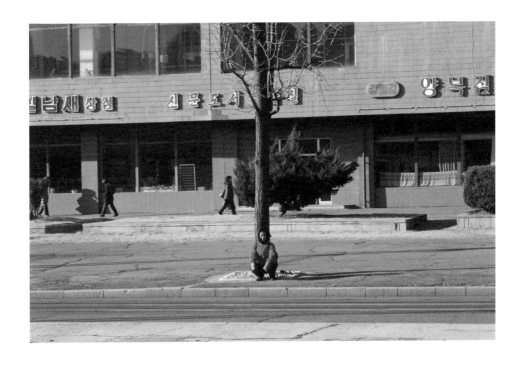

In winter, Pyongyang felt like it was shutting down. While richer Koreans donned fur hats and thick winter coats, most struggled in thin jackets and plimsolls. — Pyongyang, January 2019

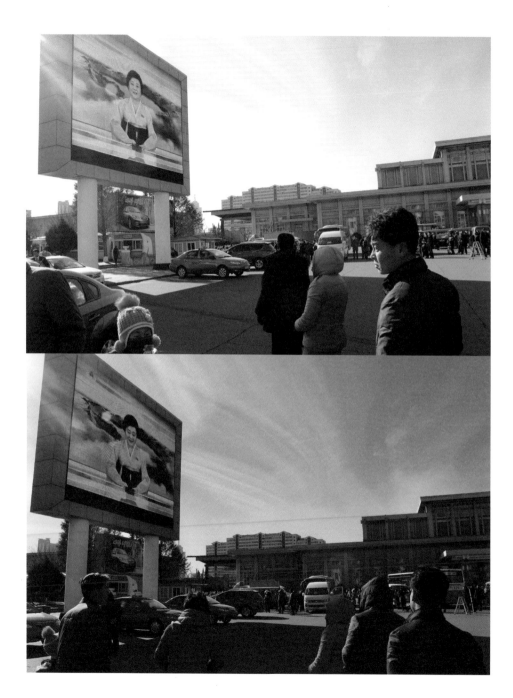

THE ANNOUNCEMENT

'North Korea appears to have launched another missile in the early hours of the morning, a missile which is thought to be capable of reaching the United States.'

There it was. Another one. The video of the latest missile test showed the rocket roaring up towards the sky, then cut away to a view of Kim Jong Un surrounded by his clapping cronies.

Winter was supposed to be a quiet time for North Korea's testing programme and so, as expected, several weeks had gone by without a rise in tensions. Koreans and foreigners alike agreed that it felt as if someone had hit the pause button. But I guess we all should have known better. I had been sceptical about the sense of calm in the air, but I hadn't for one minute thought that another missile test would be on the cards.

Throughout that morning, as I watched the TV in our apartment, more information started to appear. North Korea had launched a Hwasong-15 intercontinental ballistic missile at 3 a.m. Not only did the regime claim that it was capable of carrying a nuclear warhead, but also that it was capable of striking the US.

This was a game changer. North Korea had successfully tested a nuclear bomb and now they allegedly had means to use it against the country they thought of as their greatest enemy.

I wondered how North Koreans would react to the news. Surely they wouldn't be excited at the prospect of tensions getting worse? I stared at the packed suitcases in the hall, filled with essentials in case we had to evacuate. Was the time approaching?

Later that day, I knew, state TV would make a public broadcast to the people who, at that point, still didn't know about the test. I wanted to be there when they did.

With a few hours until the broadcast, I took myself off for a coffee at a small café next to Pyongyang's Golden Lanes Bowling Alley, where I sat in the window and watched the people passing by. There was nothing remarkable

(*opposite*) North Korean newsreader Ri Chun Hee announces the success of the Hwasong-15 missile launch to crowds outside Pyongyang train station. — Pyongyang, November 2017

about Pyongyang that morning. As I'd seen before, the eye of the storm was calmer than the panic in the West, Japan and South Korea. The scale of secrecy was astonishing. At home, I'd have had a notification pop up on my phone about any breaking news within minutes of an event. Here, there was nothing. These people had no idea. Or, at least, it seemed that way.

As it was nearing 12.30 p.m., I headed to the train station to watch the announcement broadcast by famous newsreader Ri Chun Hee on the station's big screen. Her frenzied voice soared around the city as she flashed a maniacal smile, announcing to the sparse assembled crowd that North Korea had successfully tested a missile capable of hitting the US. There was a mixture of reactions. Some people looked nonchalant about the whole thing, walking away after a few minutes. Others clapped and cheered, but there were no tearful, flag-waving hordes of supporters of the kind usually shown on state media after big events. This was more on the level of applauding a good golf shot.

But then I became conscious of an approaching dull roar. Through a crowd of onlookers appeared a formation of about a hundred people lined up in neat rows, waving flowers, clapping and crying on command. In front of them were several TV cameras of the Korean Central News Agency and a director shouting orders through a megaphone. As the people swayed from left to right and jumped up and down, their shoes thudded on the ground and their hands flailed wildly. A child across the street who was walking with her grandmother stopped to copy them; the grandmother laughed and encouraged her to keep walking.

When the announcement was over, the cameramen jumped into their minibuses and drove off, the hired crowd dispersed and the screen went back to playing movies as if nothing had happened.

This manufactured crowd was what people all over the world would see later that day when official footage was released as, apart from the Russian news agency TASS and Chinese Central Television (CCTV), there were precious few foreign journalists with a permanent presence in Pyongyang, so what ordinary people thought about their country's missile test could therefore be carefully edited and broadcast to the world. While in the real crowd of commuters, office workers, market sellers, housewives and others there was a mixture of responses that the world wouldn't get to see, from the crafted footage, Western and North Korean media, in different ways, would peddle a distorted picture of what was going on, drawing complex conclusions from several seconds of silly, choreographed B-roll.

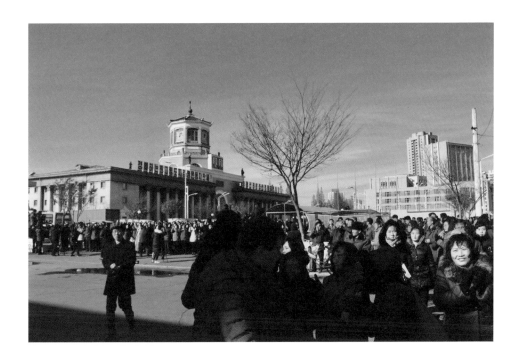

In the background, in front of North Korean state TV cameras, a crowd of men and women cheer and jump on command to the announcement of the missile test.
— Pyongyang, November 2017

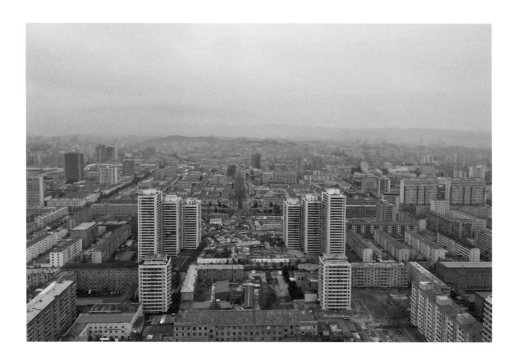

Taken from the top of the Juche Tower, one of eastern Pyongyang's poorer residential areas can be seen nestled between the city's high-rise buildings. — Pyongyang, November 2017

A man crosses the road in the plummeting temperatures of winter. In both winter and summer people would sit by the sides of the road, reading the words of the 'Dear Leader' while waiting for the bus. At night some used the streetlights for reading. — Pyongyang, December 2018

(*following pages*) In winter frozen rivers provided useful shortcuts for people walking, cycling or even motorcycling around the city. Here men can be seen cutting into the ice to fish. — Pyongyang, January 2019

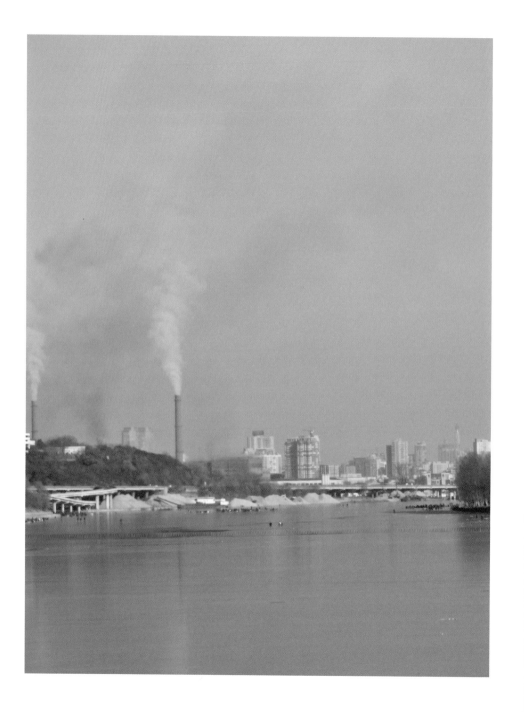

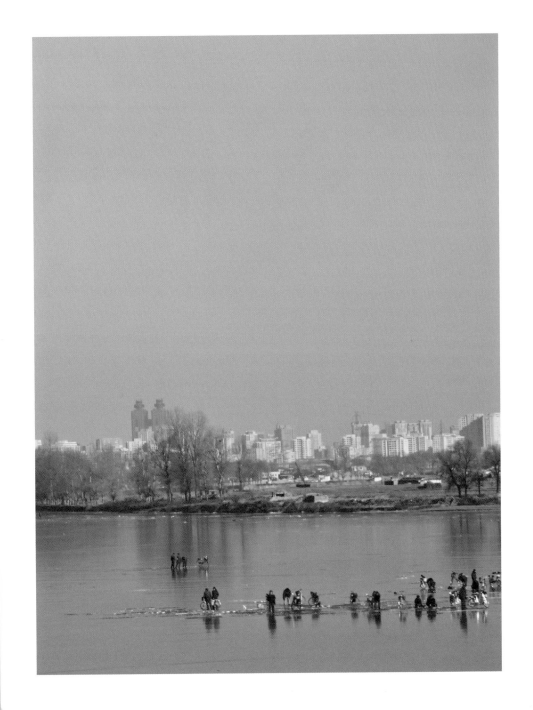

During parade preparations, bolsters and supports were placed inside underpasses leading to and from Kim Il Sung Square, to reinforce them for the tanks and military hardware that would pass overhead. Underpasses were also a popular place for school children to play football, away from the summer heat or winter cold. — Pyongyang, January 2019

Some Korean women walk home from shopping at the market. In Tonghil Market, winter was a favourable time of year to shop and sell. Many sellers preferred the cold as frozen meat and fish could be kept chilled, as opposed to thawing in the summer heat. The market itself was a huge chaotic hall echoing with the noise of sacks thudding on the floor, shoppers and sellers bartering and people crammed together gossiping and pushing past each other for the best produce. The air smelled strongly of cooked ducks, fresh meat, sour berries and cleaning fluid. All of the sellers were middle-aged women who wore blue tabards. They were a force to be reckoned with. They were competitive but had fun shouting across the aisles to each other, winding each other up and gossiping with their customers. It reminded me a lot of the markets my grandmother used to take me to in Glasgow. — Pyongyang, January 2019

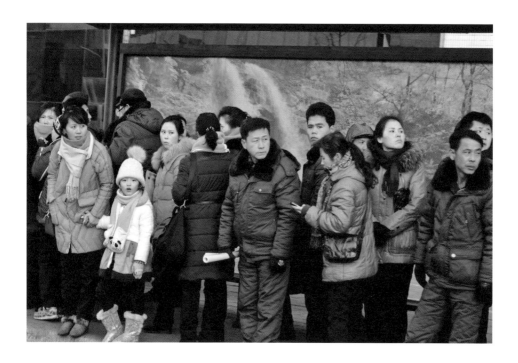

Groups of people wait for a Pyongyang trolley bus in winter. Winter was a popular time for Pyongyang mothers to accessorise themselves and their children for the season. Girls and boys across the city were dressed in hats and mittens, fluffy boots and jackets. A Korean friend told me how their daughter was always obsessed with winter clothes and that she asked for new accessories for her birthday every year. — Pyongyang, January 2019

In winter, Pyongyang's rivers freeze over, trapping boats on the riverbanks. — Pyongyang, January 2019

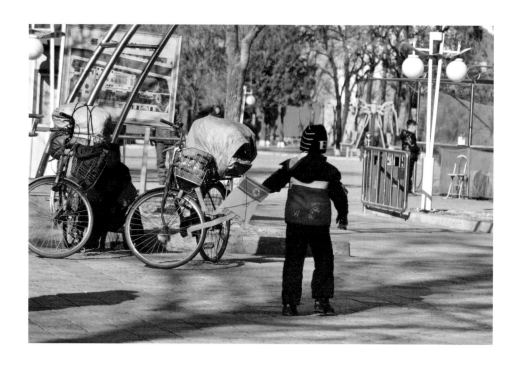

At a local park, a young boy plays with a homemade kite made from a plastic bag with the North Korean flag on the front. Homemade paper boats and planes were popular in summer. In local parks, groups of children would cheer and shout for their favourite boat as they raced them on the ponds. — Pyongyang, January 2019

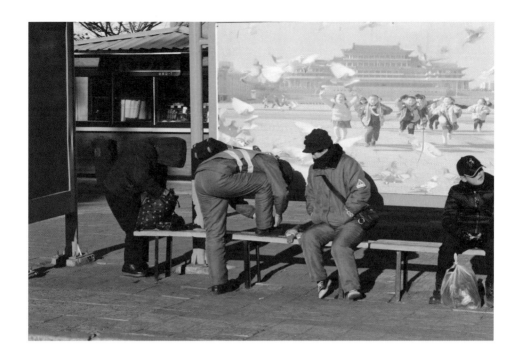

Many Koreans wore puffer coats and trousers in winter to protect themselves from the intense cold. — Pyongyang, December 2018

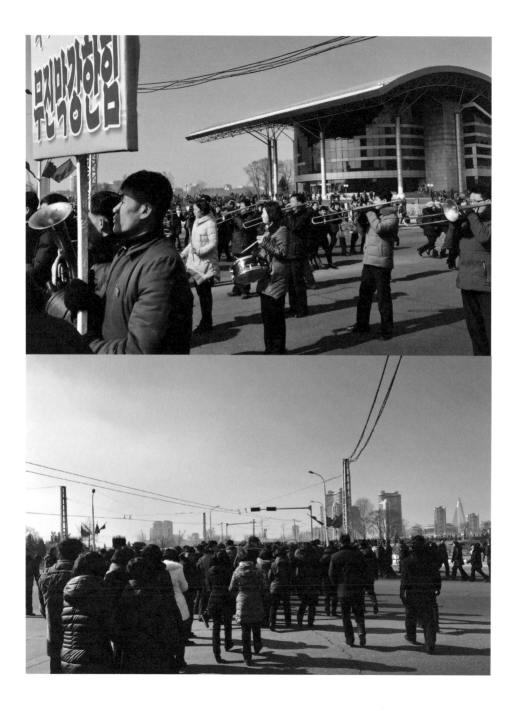

THE PARADE

It was a freezing morning. My friend and I had got up at around 5 a.m. and planned on heading out into the city at 6 a.m. We didn't know when the parade was happening and we didn't know exactly where we could go to watch it, but we figured if we went out early enough, we might get into central Pyongyang before they started to lock it down.

After only seconds of being outside, my feet had gone numb. Flags and bunting had been put up around the streets and shops had multicoloured balloons in their windows. Days before, large wooden frames had been erected to lift up the trolley-bus cables. In the underpasses, ceilings were bolstered with similar wooden frames. It was clear some big, heavy vehicles would be passing through. Roads were shut but there were no crowds yet. We kept walking down the street and towards the square where I saw hundreds of Koreans gathered on one of the bridges. Women in traditional dresses stood out from the sea of brown and navy coats and fur hats worn by the men. Small groups were crouched in the road around makeshift fires, trying to keep themselves warm. We decided to chance our luck and head across the bridge. We had nothing to lose. If we were denied access we'd just watch from somewhere else. Oddly, as we made our way past the crowds, not a single guard or police officer stopped or questioned us. When we came to the other side, there was a wall of armed soldiers blocking the pavement. They all had loaded rifles in their hands. I expected that at any moment they would warn us away, but nothing happened. Nobody stopped us. Nobody batted an eyelid. The guards simply moved aside to let us past. But before I had the chance to let out a sigh of relief, I gasped in shock.

Several gargantuan rockets were mounted on the back of trucks and tucked under thick khaki covers. Behind them, a menacing queue of artillery units, rocket launchers, weapons, trucks and tanks wound all the back towards Mansudae Hill and up towards the Chollima Statue a kilometre away. They probably went as far back as the northern edge of Moranbong Park towards the Arch of Triumph, ready to be paraded in front of the leader himself. I later

(*opposite*) Crowds gather to watch the February 2018 parade in celebration of the 70th anniversary of the foundation of the Korean People's Army. Usually the parade is scheduled for April, but in 2018 it was given a February date to coincide with the PyeongChang Winter Olympics. — Pyongyang, February 2018

learned the Hwasong ICBMs, still making the world's headlines, weren't far away from where we stood. In front of us were several military brass bands, desperately trying to warm up their instruments in the freezing cold. A couple of the musicians stared curiously at me but, understandably, looked more concerned about their fingers freezing off before the performance. We stood to the side of the empty pavement and took shelter in a restaurant doorway. The French horns and trombones squeaked and split in the background. My friend dug his hands into his pockets, pulled out a silver hipflask and passed it to me. I knocked back a shot to warm my insides. I could understand now why alcohol was a powerful tool for keeping warm in cold countries. I stood in silence watching the North Korean soldiers and military musicians pace around in a vain effort to keep warm, and I prepared to wait out the rest of the morning in the doorway. Before long a large man in a brown fur coat came out of the restaurant. The obligatory cigarette hung from his mouth as he tightened his belt. He stank of alcohol. He spotted us, said good morning, then smiled and walked off. I was beginning to wonder why we hadn't been escorted back to the other side of the river by now. If that didn't happen soon, we'd be hemmed in barely yards from what was, at the time, probably the most elaborate display of military power in the world. Maybe a silly foreigner appearing to watch the show hours early hadn't been on the orders list.

Ten to fifteen minutes later, an MPS guard approached us. He was wearing a long, smart, dark green coat which fell to his ankles. He had a matching dark green fur collar and a fur hat with a red star on the front. I could hear his boots crunching the ground as he walked towards us. Maybe it was the whisky, but I felt remarkably calm. When he arrived, he smiled and said hello with a slight bow. I offered him a shot from the hipflask. He raised his hands and laughed, refusing politely. He spoke in a rough but calm voice, and although I didn't understand him perfectly, it was very clear that we had outstayed our welcome. He pointed to the weapons in front of us and wagged his finger as if we were naughty schoolchildren. Then he ushered us around the side of the building, through a restaurant courtyard and back out towards the bridge where we'd passed the armed soldiers earlier. As we walked back across the bridge and past the hundreds of Koreans who were still sitting in their lines, I felt someone behind us. A man in a suit and a thick, quilted khaki coat was following us. He walked a few steps behind us before tailing off halfway across the bridge. I turned towards the river for one more attempt at sneaking into the parade, but as soon as I did, our escort walked towards us again. The fun was over.

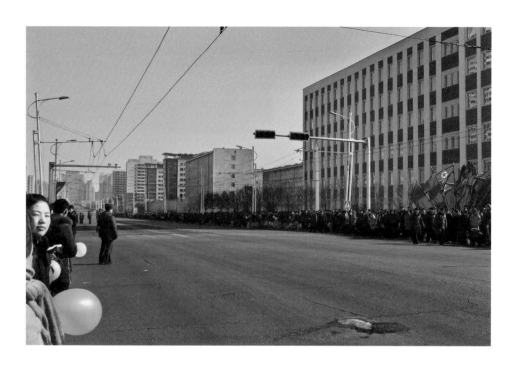

Crowds braved the cold on Tongdaewon Street to watch the passing parade, which made its way from Kim Il Sung Square through the city. During military parades, some foreigners would notice that their mobile phone signal would disappear, only to reappear later in the evening. — Pyongyang, February 2018

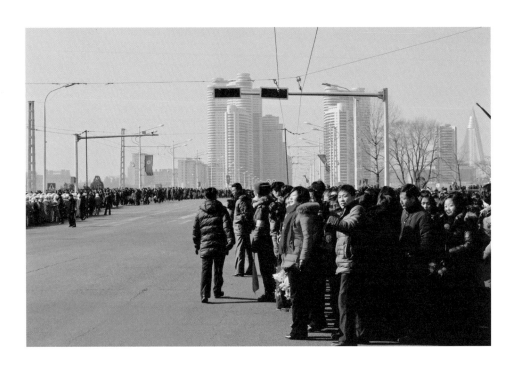

Many students, on spotting foreigners in the crowd, were keen to take the opportunity to practise their English. On Okryu Bridge, one told me about how excited they were to have an afternoon away from studying, even if it meant standing in the cold. — Pyongyang, February 2018

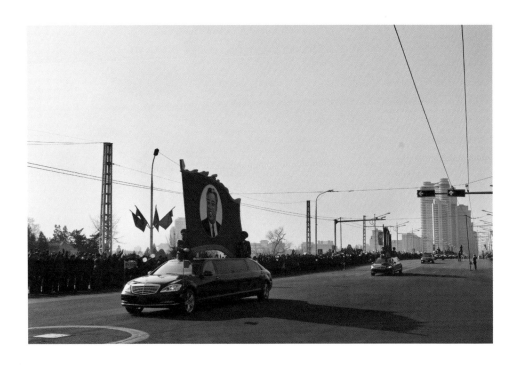

Limousines displaying giant images of Kim Il Sung and Kim Jong Il opened the parade, to clapping and cheering from the crowds. Many people waved their flags in appreciation of the leaders. — Pyongyang, February 2018

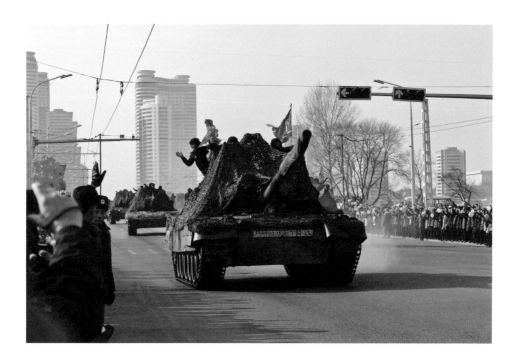

The foreign community was rife with theories about whether North Korea's army had been left to go to ruin, or whether more modern and effective conventional weaponry was being kept secret. Military parades were therefore a useful opportunity to see the state of the North Korean army's hardware. Of course, photographing ballistic missiles up close was next to impossible. — Pyongyang, February 2018

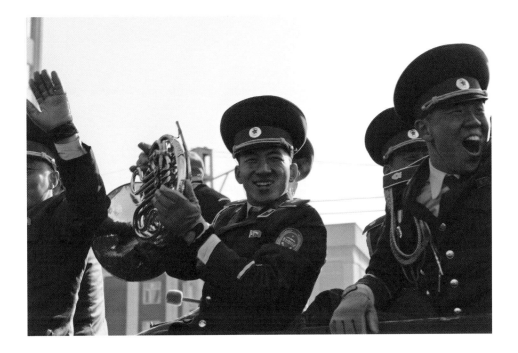

A French-horn player raises his instrument to the roaring crowds. For many soldiers who ordinarily endured long days of monotonous hardship, parades felt like their one day to be a hero; to be admired by younger and older generations and to feel like they were truly contributing towards the future of their country. The propaganda power of this parade marking the creation of the Korean People's Army was undeniable. It felt like a truly joyous and proud occasion, where people genuinely celebrated. It's naïve to assume that the North Korean people don't feel any sense of pride or joy on days like this because life is so hard for so many. People seemed genuinely happy. While North Korea often felt like one big grey area, this was not one of those times. — Pyongyang, February 2018

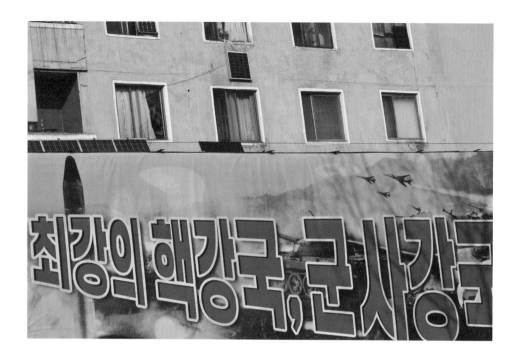

A propaganda sign refers to North Korea's nuclear programme as the cornerstone of its military power. In the days following the parade, the PyeongChang Winter Olympics began, and propaganda such as this was less common to see around the city. Instead, slogans were seen promoting the prospect of North Korea's economy, and future generations. — Pyongyang, February 2018

As the huge crowds dispersed from military parades, enormous queues formed at the bus and tram stops across the city. This group of girls regularly stopped to take selfies as they made their way home. — Pyongyang, February 2018

Students carrying propaganda signs made their way to one of the many coaches waiting across the city to take them back to university. Students, work units and women's groups were bussed in and out of events. Crowds of people could be seen gathering and sitting in order, before being allowed to board. — Pyongyang, February 2018

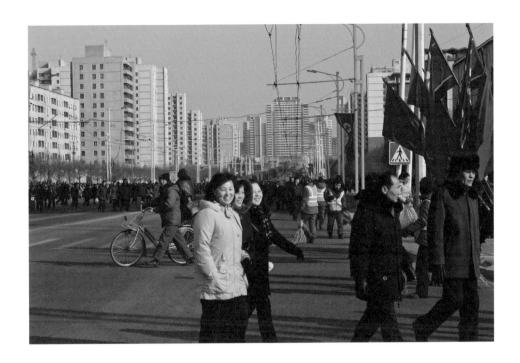

Cleaners swiftly attended the streets. Poles holding up the electricity lines were also rapidly cleared away. Within an hour or so, the streets of Pyongyang looked as if nothing had ever happened. — Pyongyang, February 2018

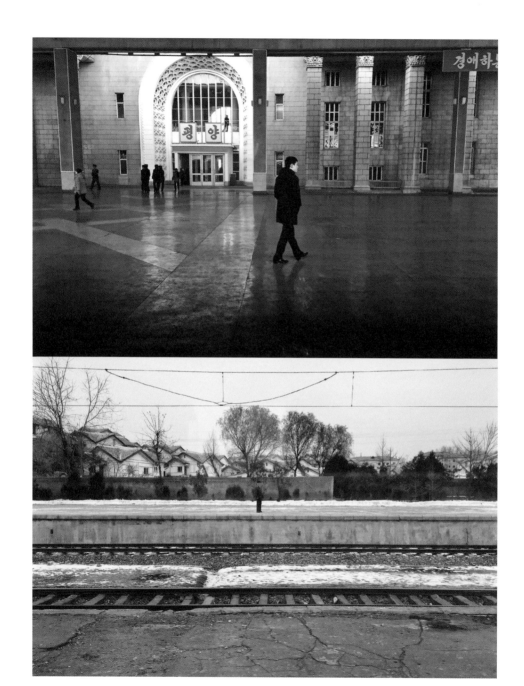

THE TRAIN

It was pitch black outside, the only lights flashing past the train window came from the odd house or factory in the distance. It would be another twelve hours before we reached China. Full of salty noodles and beer, I opened my laptop to watch an episode of *The Wire*.

I'd barely got into the first scene when there was a knock on the door of my cabin. The door slid back, revealing the eager face of the train conductor. He was wearing a discoloured white vest and smelled strongly of cigarettes, *soju* and felt-tip pens. He said hello and sat down confidently next to me on my bed. Seconds felt like hours as I waited for him to say something. Then he gently tapped me on the arm, offered a friendly smile and shook my hand. He said his name was Pak. I introduced myself in return and we bowed our heads to each other.

Pak was forty-five years old and had two daughters in Pyongyang. He had studied English at university but that had been a long time ago and his spoken English wasn't great now. Hearing I was British, his face lit up and he started to sing 'Hey Jude' in a characteristically North Korean style, which is to significantly lengthen each vowel sound for dramatic effect. We sang a chorus together and giggled.

Pak pointed to my laptop and asked me what I was watching. I told him it was called *The Wire*. Then I stopped. How was I going to explain? My Korean was limited. I could just about ask for directions, never mind explain the story of American narcotics gangs in Baltimore. So, I stood up and started putting years of playing charades to use.

As soon as I raised my hands to make a gun, Pak also stood up and made a gun of his own hand, wiggling his thumb as he made shooting noises. 'Ah, American police! Always bad! American police bad with American people!'

Maybe the evils of American policing were a regular fixture in North

(*opposite top*) Unaccompanied foreigners were not allowed to enter through the main entrance to Pyongyang train station, but through a modest door to the side, which led to a small room where ID cards were checked by a woman in a blue uniform. Accompanying guests to the platform incurred a 1 euro fee. — Pyongyang, December 2017

(*opposite bottom*) A solitary soldier stands on a freezing platform at a desolate train station. — North Pyongan province, December 2017

Korean news. Then I remembered he was a frequent visitor to China, which, for a North Korean, was a great source of information.

When I had finished my re-enactment he applauded and I took a little bow. Laughing, he pulled a small, half-empty bottle of *soju* from his pocket and offered me some. I pointed to my beer and told him I was fine. He took a swig from the bottle and asked, 'I watch?'

I didn't have a problem with us watching some of it together but I knew someone, somewhere, surely would. I wondered if the *soju* had been a confidence booster and how many times he had asked the same thing of other foreigners. I switched on the subtitles to give him half a chance, but even they weren't much help, given the speed at which the characters spoke.

We wobbled along side by side as the train clunked along the rickety tracks. Pak's eyes remained fixed on the screen. I found myself becoming nervous. I was trying to anticipate sex scenes or bad language. I felt like a teenager, watching a movie with my parents.

'What a bitch!' he shouted suddenly, sounding out the subtitles in a strong Korean accent. 'Fuck you!' He rolled around laughing at his attempt to speak English, with absolutely no idea of what he was saying. 'Motherfucker!'

'No, no!' I laughed, waving my hands in front of me. 'Stop, stop!'

It was too late. Ten minutes with me, and Pak had gone from basic English to swearing like a trooper.

He stood up and started to pretend to shoot again and I joined in. He pretended to get shot and threw himself back on the bed in hysterical laughter, and I couldn't help laughing too. As the video continued to play, we sat in silence for a few moments, taking time to recover.

I wanted to give something to him: something to thank him for his company. I felt in my pocket and discovered a bar of chocolate that I had brought from home. I handed it to him and told him it was a gift. He held it gently on his open palm, the chocolate bar swamped by his large hands.

'England chocolate?' he asked.

I nodded.

'England chocolate very good. For my family.' He gently tucked it into his pocket as if he was trying not to break it. 'Thank you,' he said slowly. I nodded, and we smiled.

He extended his right hand towards me and shook my hand.

'Friend,' he said.

'Friend,' I replied.

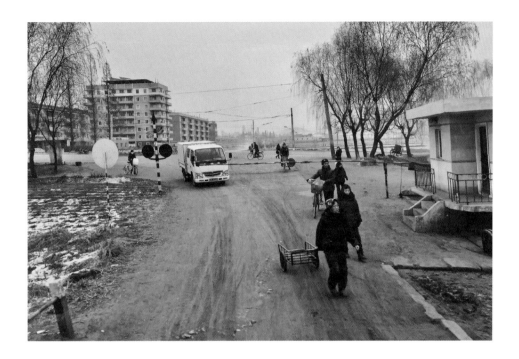

There were two train services which operated between Pyongyang and Beijing: one was run by the Chinese and the other by the Koreans. On this journey I took the North Korean train. The cabins smelled of stale tobacco and old vacuum cleaners and beds were decorated with very 1970s-style dusky pink, fringed velour mattress covers. Towns along the train line from Pyongyang to Sinuiju showed another side of life. Far fewer people wore fur coats and hats. Fewer cars could be seen on the roads. Roads were dustier and rockier. In the countryside, people could be seen working in the middle of frozen, brown and barren fields with no one else around for miles. At random intervals on the train journey, Koreans often had to reveal contents of their suitcases and bribe customs guards or secret police. Foreigners weren't exempt from this practice. A friend once told me that they had been allowed to enter the country with movies considered illegal by the North Korean customs guards until a turn of the head was offered for $10 and two packets of cigarettes. — North Pyongan province, December 2017

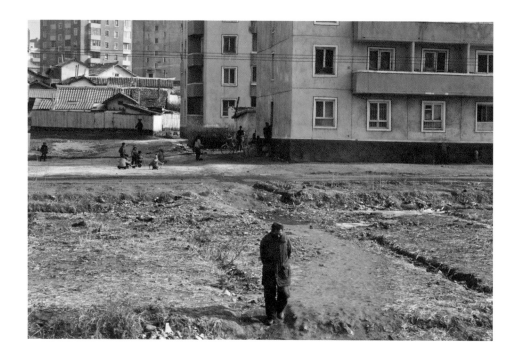

(*above*) A less common sight in Pyongyang, here apartments blocks and 'harmonica houses' sit side by side. This man had been burning rubbish out of shot before making his way towards the train line, leaving children playing in the snow behind him. Some threw a few snowballs at his back. The man, unaware, kept walking. — North Pyongan province, December 2017

(*opposite*) Children regularly ran up to the train to see who was on board. Many of them smiled and waved to the strangers in the carriages. It was impossible to communicate with anyone outside the train other than through physical gestures, as all of the windows were sealed shut. — North Pyongan province, December 2017

This house had several dogs running around on the path outside. A couple of children played with the younger puppies. It was more likely that the animals were to be used for meat than kept as pets. Cyclists with cages of puppies strapped to the seat were a common sight in the countryside. — Unknown village, January 2019

Children played with homemade sledges and ice skates in winter, pushing themselves along the frozen ponds and rivers with sticks and laughing when they fell over. Rural villages tucked away in the mountains were mostly dark and deadly quiet at night. The only lights that could be seen were from torches tied to the handlebars of bicycles, bumping along in the dark. — North Pyongan province, January 2018

Traditional Korean houses such as these were unlikely to have changed since before
North Korea existed. These were the same style of house which could be seen in the
preserved traditional village in the city of Kaesong. — North Pyongan province,
December 2017

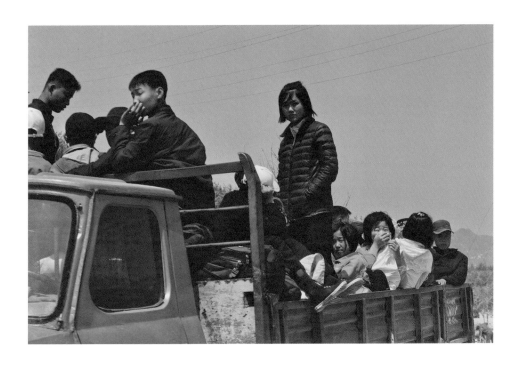

These children were being transported on the back of a truck on the road to Sinuiju. I always wondered where these groups of people were going. Some could have been hitchhiking, some could have been on their way to work, some could have been making their way back to Pyongyang. Generally, there was no way of knowing. — North Pyongan province, May 2018

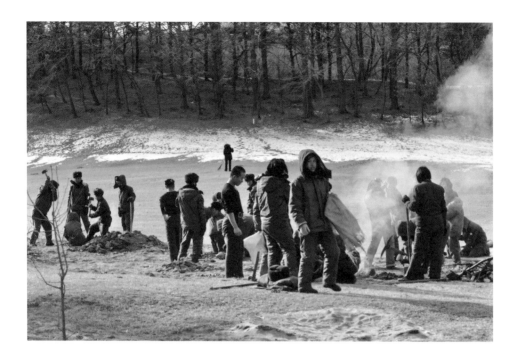

Pyongyang golf course closed during the winter of 2018 for redevelopment and, a year later, was still closed. A large number of accommodation blocks were being built, along with a new pop-up restaurant at the tenth hole. Hundreds of soldiers seemed to be living on-site and working across the course to create a product more amenable to foreign golfers. — Outer Pyongyang, January 2019

A small vehicle carries building materials to construction workers at Pyongyang golf course. This new gravel road diverted traffic away from the villages, thereby reducing any future opportunities for visitors to mix with local villagers. The old road has since been blocked off. — Outer Pyongyang, January 2019

The Pyongyang Club House was always empty. It seemed also to be understaffed, and most visits were spent trying to find someone who worked there. The huge restaurant, also always empty, was freezing cold. Lights and music were turned on for the few foreigners who visited, but immediately turned off again after they left. — Outer Pyongyang, August 2018

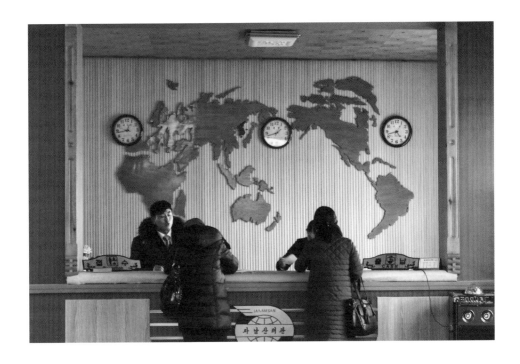

Two tour guides settle the bill for a meal at the Janamsan Hotel while on a tour of the area. The map on the wall, with North Korea highlighted at the centre of the map in red, was a common design seen in many buildings. — Kaesong, December 2018

THE SHOP ASSISTANT

'Hello, how may I help you today?'

I was shocked. The smiling shop assistant seemed to have an almost British accent. She looked at me expectantly while her colleague kept her head lowered and avoided eye contact. What was a confident English speaker doing working in a dingy shop like this, where there was nothing to draw foreigners in?

'Your English is excellent. How do you speak so well?' I asked. The girl giggled and thanked me. She told me that her name was Miss Han and that she had studied at the Pyongyang University of Foreign Studies, where she had been one of the top students in English and Spanish. As she rattled on about her student days, I was mesmerised by her flawless command of the language.

'Hold on,' I said. 'You speak Spanish?'

She nodded. For the first time in years I put my Spanish to use and spoke to her in our second mutual language. She gasped. I told her that I had studied French and Spanish at university. She jumped up and down and clapped excitedly.

'Me, too!' she said in Spanish. 'I lived in Cuba and Peru when I was younger and went to school with many Spanish-speaking children. Actually, I had lots of English and American friends when I went to school.'

I had to remind myself that I was speaking to a North Korean girl. How on earth was it possible that she had grown up abroad and had international friends?

'My father is a diplomat,' she said. 'We travelled a lot and so I had many international friends.'

There had been something unusual about this girl from the moment I saw her. She radiated openness and was obviously comfortable being around a

(*opposite top*) A local flower shop window display, close to the Munsu Dong district.
— Pyongyang, December 2018

(*opposite bottom*) Department Store No. 1 displays sporting items for sale. The shop stocked many famous sporting brands, with members of the foreign community often wondering if they were perhaps locally produced. Even though boxing gloves were displayed in the window, they were not for sale inside the shop. Sporting equipment was often expensive in Pyongyang, with one sports shop selling a football for $300. One week the football mysteriously disappeared from sale and rumours spread around the foreign community as to who, desperate for a final souvenir, had more money than sense.
— Pyongyang, January 2019

foreigner, unlike the girl behind the till, who still kept her head low but was obviously trying to follow what we were saying. It was amazing how differently Koreans who had experience of the outside world behaved, compared to those who had never left or would never leave. It felt like there was some kind of understanding that foreigners were not a threat. It was a relief to be treated normally.

The girl told me that the Spanish language reminded her of many happy times in South America and that she rarely had the chance to practise now. She had been very happy there: she loved the people, the food and the music, and she wanted to go back again one day. She kept telling me about her many international friends and seemed determined to convince me that she liked Americans and Brits. I sensed she assumed I thought all North Koreans hated Westerners, particularly Americans, and she didn't want me to think that about her.

I felt deeply sorry for her. She was obviously a talented linguist, and a bright, friendly girl, and yet she would spend the rest of her life hidden away from a world full of opportunities. What kind of life would she have had if she had been born elsewhere? What would she have seen? Who would she be?

I asked if she was able to keep in touch with any of her foreign friends, but I knew the answer. Her smile disappeared, she hung her head and for the first time avoided eye contact with me.

'No,' she said. 'No contact.'

My empathy surged. I wanted to call out the unfairness of the tight chains that North Korea had imposed on her. I wanted to help her get out and have a normal life, a life where she could achieve, excel and be free. But, as always, there was nothing I could do. We couldn't even do the things most strangers do when they make a connection with someone: swap phone numbers, go for coffee, or meet each other's friends and family. I looked at her and smiled, trying to communicate through my eyes everything I couldn't say out loud.

Miss Han took my items to the till as the silent girl kept her head bowed. She punched the total amount into a calculator and put out her hand for the money. Miss Han tapped the girl's arm and she finally lifted her head to look at me, blank-faced. As I handed her the money I smiled and thanked them both for looking after me. They both bowed their heads and Miss Han told me in Spanish to come back again soon. On the street outside, I turned around to see her face poking out from the blinds in the window, as she gently waved me goodbye.

Dolls in traditional Korean dress were sold in many tourist shops across Pyongyang. Most products sold in these shops could be bought at the local market for a fraction of the price; however, tourists were not allowed to visit the markets. — Pyongyang, January 2019

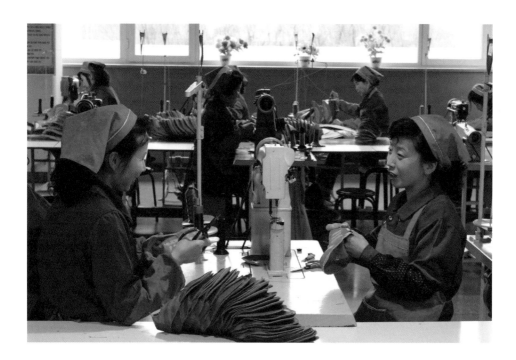

Workers talk while members of the foreign community are shown around the shoe factory. My seventeen-year-old guide, a young student from the Pyongyang University of Foreign Languages, fiddled nervously with her notes, which contained all of the statistics and information to relay to me. After a short while, we stopped discussing shoes and instead got to know each other. Interestingly, she told me that the factory explicitly copied foreign shoes and had a display of big-brand trainers and boots, so they could be reverse designed. She preferred glittering stilettos, like other young women of the Pyongyang elite. — Pyongyang, April 2018

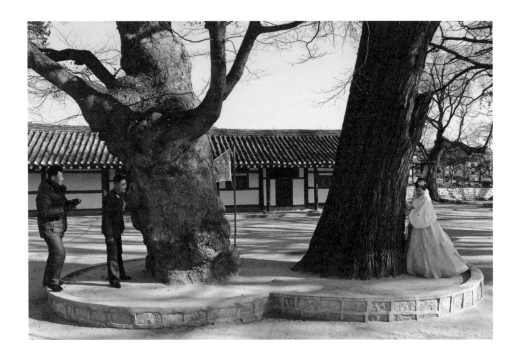

A newly married couple film a wedding video in the grounds of Songgyungwan, the most prestigious educational institution during the Koryo and Choson dynasties. The camera director asked the couple to dance under the trees and walk around the grounds, laughing and smiling together. A small wedding party cheered and clapped in appreciation. This photograph was taken on a trip to Kaesong, which is only possible when accompanied by an interpreter or tour guide. — Wonsan, December 2018

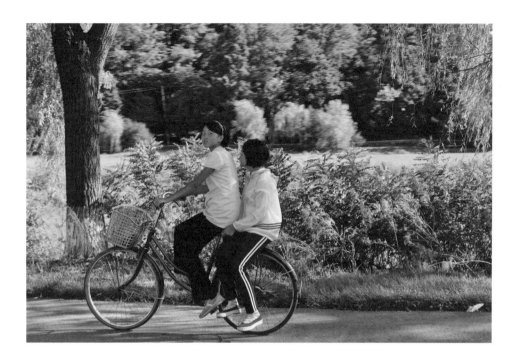

Two girls cycle along one of the roads connecting Nampo city with its coastal villages. It often appeared like mother-daughter relationships were the same as anywhere else. Friends who were mothers spoke about their wishes for the daughter's futures; a good job, a husband, children. Other friends would talk about how their mothers were old-fashioned, how they were terrible at texting and skincare tips they had inherited from them. — Nampo, September 2018

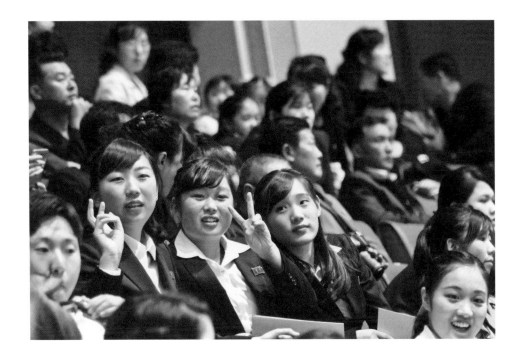

Taking selfies at the Pyongyang Mass Games. The young Korean elite are the most exposed of any North Korean generation to the outside world. It is now old news that North Koreans routinely access South Korean movies, television dramas and music. They dress in outfits and cut their hair in modern styles seen in China and South Korea, and wear jewellery and use personal accessories which, under the rule of Kim Il Sung and Kim Jong Il, would have been banned. Perhaps more importantly, theirs is the first generation to have experienced (and harnessed) the benefits of networked technology. I saw many young Korean people in Pyongyang with Samsung mobile phones and iPhones (which were prohibited by the regime because they could connect to foreign signals). Legally, young people used their Chinese-made, local-branded phones for browsing the North Korean intranet, online shopping, gaming and social networking. Slowly, the Pyongyang elite are gently eroding the North Korean regime's omnipotent hold on information. — Pyongyang, August 2018

'To strong women!' said Sohyun, downing her beer as if it was water, before slamming her glass on the table in victory. 'Three more, please!'

Sohyun, one of the guides, spoke perfect English and laughed like a hyena. Today she was in a party mood. She danced in her seat to the bellowing karaoke machine and clapped merrily every time a new plate of food arrived at the table. The other guide, Miss Kang, who was very quiet, lifted her beer to her mouth with two hands and sipped daintily, as if it was a hot cup of tea. She looked uncomfortable.

A group of young, twenty-something Koreans sat at the next table: a young married couple next to each other on a bench, opposite two female friends. They all looked very drunk. Every few minutes the girl would grab the man's face and start kissing him, while the two female friends fixated on their mobile phones. On their table rested a large pitcher of beer with coloured lights inside, turning the beer blue and green. A half-finished bottle of Johnnie Walker, which would have cost at least $100, was opened regularly and shot glasses replenished for toasts, with most of the whisky pouring over the edges onto the wet, sticky table. Even after eighteen months in North Korea, I still couldn't believe some of the lifestyles enjoyed by young people.

The waitress arrived with our second round of beers. Sohyun picked up her beer and clinked it against our glasses, before gulping it all down quickly and once again slamming the empty glass on the table.

Sohyun told me about her 'weight problems', dating mishaps and relationship breakdowns. She believed the reason she was still single was because she wasn't suited to a relationship. She wanted a career and wasn't enthusiastic about getting married or having children. But her parents had other plans. She explained that, for most North Korean girls, dates were arranged by their parents, but that was starting to change.

'My dad set me up with a really boring guy a few weeks ago. We went for a walk together and he would only talk about work. I hate dating,' she said, all the while texting on her phone. 'It's fine if I decide I want to see someone but I just don't trust my parents.' She flicked back her hair. 'I have lots I want to do,' she said. 'I want to travel and go to Paris. I want to have a career. I don't want to be stuck looking after a lazy husband and whining children while I'm in my good years.'

This obviously resonated with Miss Kang, who stopped arranging her rice with her chopsticks and instead raised her beer glass to tap ours in agreement.

I was constantly surprised by Sohyun's boldness and fearlessness around foreigners. She was so open about her wishes, which were completely contrary to the limitations imposed by the regime. She made me wonder what else Koreans would talk to me about if there was no wall between us.

The waitress brought over more beers and set them down in front of Sohyun, whose neck had flushed red after the first two glasses.

'Tell me, Lindsey, did you see the Michael Palin documentary?' she shouted now, over a student's drunken rendition of Westlife's 'My Love'. I knew what she was talking about. I told her I hadn't seen the documentary, but I had managed to catch little clips of it. She looked disappointed.

'What's wrong?' I asked.

'Oh, my friend was Michael Palin's guide. I wanted to know how it was.' She took a swallow of beer. 'We were role-playing for weeks. We practised lots of questions in our offices. She was one of the best at answering, which is why she was chosen. I wish I could have done it but it wasn't meant to be,' she said, shrugging her shoulders.

Sohyun put her head on my shoulder and took my arm in hers. I turned to see Miss Kang's reaction but she wasn't in her seat any more. Instead, she was standing centre stage, giving her best performance of 'My Heart Will Go On'. Every table in the bar was up on their feet, hands in the air and arms around each other, singing the chorus as if they were at a football match. It felt like we could have been anywhere, hanging out as friends. But I knew that this friendship, like all others, would be short-lived, so I had to enjoy it while it lasted. The shy girl who had barely said a word for the entire day danced, played to the audience and finished her performance with a bow, leaving the stage to rapturous applause.

'Do you know the term "dark horse"?' I asked her when she returned to our table.

She nodded and laughed behind her hands.

In Pyongyang, children are the pride and joy of the family. For the elite, young boys in particular are often spoilt, to the point where many have developed weight issues – a stark contrast to the North Korea of the 1990s. This is very much a Pyongyang problem: the rest of the country is still suffering from malnourishment and food security issues. — Pyongyang, July 2018

Traditionally, mothers carry their babies on their bodies; recently, however, more and more parents are using prams and strollers – another sign of disposable income among the Pyongyang elite. As a foreign woman in Pyongyang I was often confronted with the question of why I didn't have children. While some young female Korean friends also stated that they didn't want to have children, they admitted that it was still an unpopular view among the older generations. — Pyongyang, August 2019

Two young boys push a loaded cart along the road to help their grandfather. The boys were shouting words of encouragement as they pushed the trolley. While a Korean friend spoke about his imminent retirement and his wish to keep working, others in North Korea are not so privileged to experience this dilemma. — Nampo, September 2018

A young mother helps her child jump from some steps in Nampo city. While most North Korean people have only one child, I met a few who had two children. A Korean friend with two daughters said they were disappointed they had two girls, especially after the doctor had predicted both children would be boys. — Nampo, September 2018

Children around Pyongyang could often be seen playing in the public parks and green spaces well into the evening. According to a Korean friend, it's a rarity for children to play outside now that video games and phones are more popular. — Pyongyang, September 2018

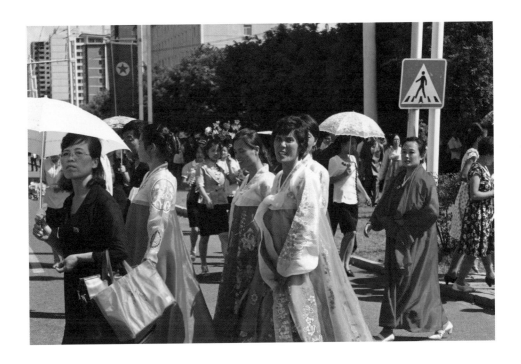

Women in traditional dresses gather in the streets of Pyongyang for a military parade. Many would have just finished performing for Kim Jong Un in the square behind. This woman had left her handbag with her husband, who was chasing her down the street to give her glasses to her. — Pyongyang, August 2018

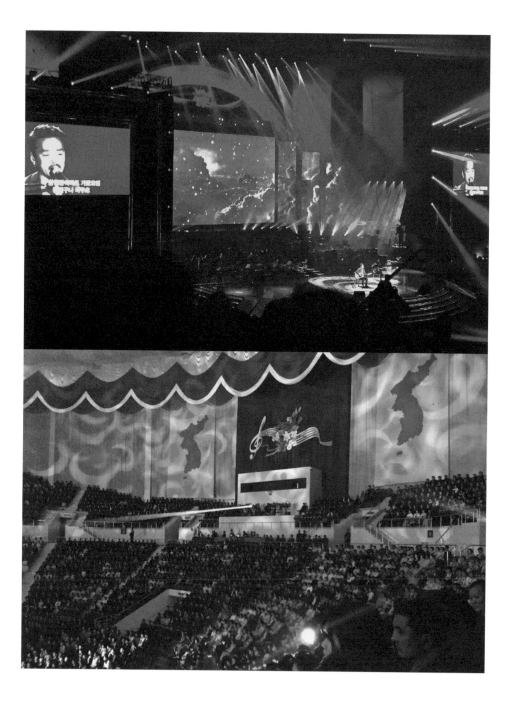

THE POP CONCERT

A young South Korean man sat centre stage, under dark blue lights, with his guitar. The thousands of onlookers in the auditorium stayed silent. He put his guitar on his knees and began talking into the microphone.

I asked my interpreter, Mr Song, to translate.

'His parents were from North Korea and ended up in South Korea during the war,' he said. 'They died recently, and their dying wish was for him to perform in their home country. He is very glad that, although they are not around any more, he can fulfil their dream.'

Mr Song let out an almost inaudible sigh. It was stirring to hear a South Korean in North Korea speak so candidly about their family and connections to the country that they were not allowed to love. How must they have felt knowing that, after the war, they could never go back?

The performer, who had wept as he introduced himself, wiped his eyes and started singing.

Sitting in front of me were three women who seemed to be from the same family. An older lady in a turquoise two-piece suit sat next to what I assumed was her daughter and her granddaughter, both of whom were dressed in their colourful traditional dresses. The youngest girl, who seemed to be in her twenties, stared at the smoky stage, her face expressionless. The grandmother, who had spent most of the show chatting endlessly, had become subdued, listening intently, her eyes glistening in the blue lights as she rested her hand on her daughter's knee. Her daughter, who was seated in the middle, had also become quieter and more reflective, leaning in to the hypnotising words of the singer.

After the performance I asked Mr Song how he had enjoyed the show. He put his hand on my shoulder. 'We are one. We are one, Mrs Lindsey. This is a very special message. We are one. We are one,' he kept saying over and over.

As we drove back to the compound, I started playing the videos I'd taken on my phone, one including the speech by the South Korean guitarist. Mr Song leaned across and switched off the car radio, so that all we could hear were the words of the South Korean guitarist. Mr Song stared along the road into the distance as the guitarist said once more: 'We are one.'

(*opposite*) The North and South Korean pop concert. Foreigners were invited to attend with only fifteen minutes' notice. — Pyongyang, April 2018

A student and fellow classmates wait for a bus to take them to rehearsals for the Pyongyang Mass Games, the biggest gymnastics display in the world. In 2018, it was the first time the games had been held after a five-year hiatus. Over 100,000 performers took part in the display, with participants as young as five years old.
— Pyongyang, September 2018

In large, outdoor spaces across Pyongyang, groups rehearsed for the Mass Games throughout the spring and summer months. Many more participants were bussed in on the backs of trucks and lorries from the surrounding areas. — Pyongyang, September 2018

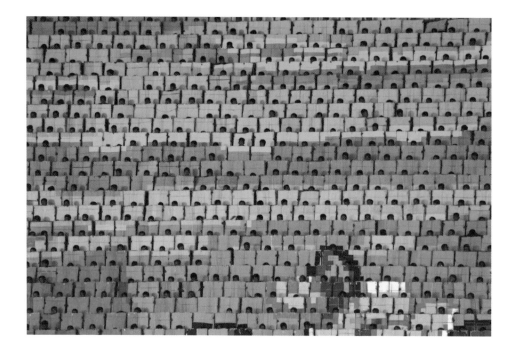

A wall of people at the Pyongyang Mass Games. Stretching the length of the Rungrado May Day Stadium were thousands of people from various Pyongyang districts. Their job was to change coloured cards on cue, thereby creating a huge mosaic of propaganda images. The 2018 performance, entitled 'The Glorious Country', displayed many messages of inter-Korean cooperation and peace. South Korean President Moon Jae-in attended the event with Kim Jong Un. — Pyongyang, August 2018

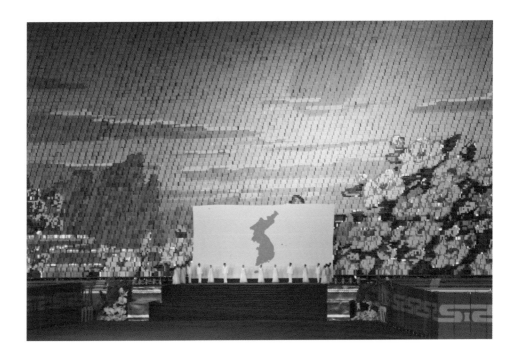

The reunification flag, an important symbol of peace and cooperation between the two Koreas, featured heavily across Pyongyang buildings, in shops and on television in 2018. The Mass Games that year were a powerful event at a moving time where enemies were declared as friends. It was impossible not to be swept up in the wave of positivity and hope generated by events such as this, and it was clear to see the effect on the thousands of smiling, hopeful faces in the audience. — Pyongyang, August 2018

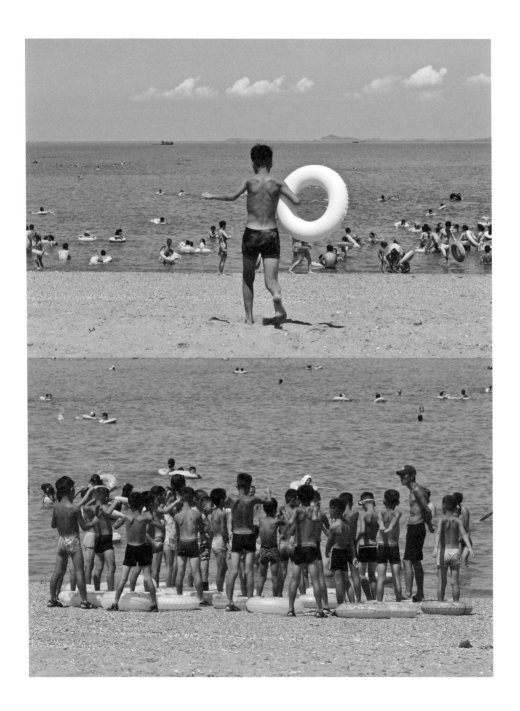

THE BABY

It was a hot summer afternoon and as a way of resting from the immense heat of the day, I had taken a turn into a local forest – and stumbled across a water park tucked away among the trees. As usual there were no signs indicating where or what it was, but that didn't seem to affect its popularity.

I was curious. I had been in Pyongyang for over a year now, but I still felt like I had so much to find out and learn about the place. I parked the car and walked up the steps to a restaurant which overlooked the park. People were splashing in the crystal-blue water, falling off multicoloured rubber rings and pushing each other down bright yellow and red water slides. Women and men were doubled over laughing at each other as they missed important volleyball shots and kicked each other on the bum by way of penalty. I ordered myself a beer and took a seat, watching the many families who were also enjoying a cold drink, some rolling ice-cold bottles of beer over their hot, burned skin for relief.

As I was taking in the view an old man approached me. He was accompanied by two little girls who held on to his trousers, both sucking their thumbs. His face was worn and thin, but his eyes were full of life. He was holding an inflatable yellow rubber ring in the shape of a duck in his hands. I could smell the *soju* and beer on his breath, and his cheeks were flushed and glowing. I had a quick glance over to his family, who were watching him whilst giggling to each other. They were crouching around a sizzling, smouldering barbecue, surrounded by empty green Taedonggang beer bottles. I said hello to the children. They gasped, then whispered, 'She speaks Korean!' to each other. The man laughed and introduced himself as Han Yongchul. I introduced myself in return and we bowed to each other. I could see the waitress peeking around the door in the corner.

He presented me with the rubber duck as if he was passing a crown at a coronation. I automatically reached out to take it and he placed the rubber duck in my hands. The weight of the toy instantly forced my arms down: in the middle of the duck, wrapped in a pink blanket, was a sleeping, new-born baby

(*opposite*) Swimmers of all ages take to the water at the beach in Nampo. Young boys were playing football on the sand while groups of older Koreans played volleyball, kicking each other playfully on the bum if they lost a point. An official beach photographer carried an inflatable rainbow, offering swimmers photographs for 1,000 won (about 10 cents) each. — Nampo, August 2019

girl. I don't know what my face must have looked like, but Han took one look at me and laughed, as did the others, who were still sitting around the barbecue. I felt confused and panicked. 'What am I supposed to do?' I thought. 'Why is he handing me this baby? Is this allowed?' I looked down at the child. Her little pink lips pursed as she blew tiny glistening bubbles. I brushed a delicate strand of hair from her eyes. She was so soft and fragile. I told the man she was beautiful and asked her name.

'Yué,' he replied. He asked if I had children and when I replied that I didn't, he laughed and told me to hurry up, pointing to the shiny gold watch on his wrist. I rolled my eyes and nodded as he giggled. We stood there together in comfortable silence for a few precious moments. I held little Yué in my arms and lowered my head to hers, holding her as close as I could without waking her. I sang her 'Edelweiss', the song my mother used to sing to me when I was a baby. As I whispered the lyrics into her tiny ear, I wished that her future might be more free. Already she was sentenced to her leader's vision of a suitable life.

After a few minutes, I heard the sound of shoes clicking up the concrete stairs. The sound was wrong: no one was wearing anything other than flip flops and sandals. I swiftly passed the baby back to her grandfather, who was looking at something behind me. He took the duck, smiled at me and started to walk away, hurriedly rejoining his family with a sobering look of concern in his eyes. The children followed him, still clinging to his trouser legs. I continued to drink my beer, affecting calmness.

Out of the corner of my eye I could see what Han had been looking at. A man in a suit had arrived at a table a few metres away from me. He ordered a beer and pointed his chair in my direction. The message was clear: *Stay away from her. Stay away from the foreigner.*

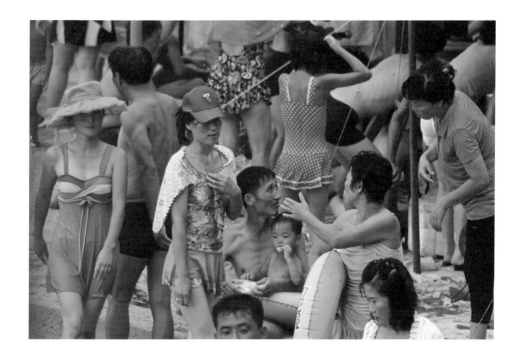

The chaotic beach smelled of cigarette smoke, barbecues and lighter fuel. Groups ate, drank, danced and sang to the many karaoke machines that were all blasting out different songs from under myriad makeshift canopies. One man dressed in nothing but his underpants stood over a large net of flaming clams. With drunken joy, he squeezed a continuous cable of petrol over the fire while his family cheered him on. As the flames leapt higher, he didn't seem bothered by the cigarette hanging dangerously from his mouth. This father fed the meat of the hot shellfish to his son. — Nampo, August 2019

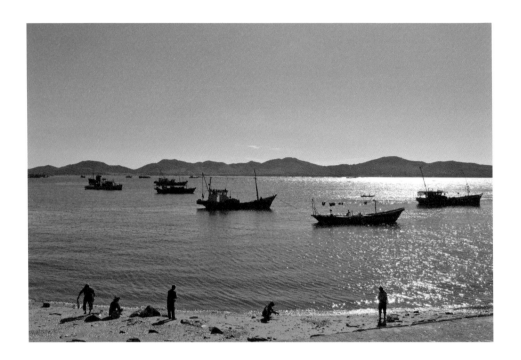

A group of older Korean men fish on one of Nampo's smaller beaches. Some of the rusty fishing boats bobbing up and down on the water had freshly laundered clothes hung out on washing lines tied between their mast and bow. Some fishermen shouted playfully across to the men on the beach, mocking them for their modest catch. The men didn't seem to care much, with most of them looking like they were there for the pleasure of the experience rather than having something to take home. — Nampo, September 2018

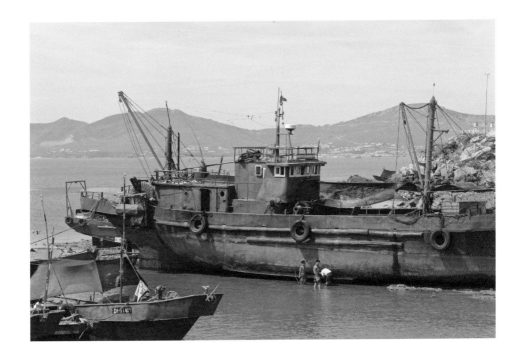

In North Korea, nothing goes to waste. Just as with other things, boats are repaired over and over again to keep them running as long as possible. I always wanted to know how old these boats were, where they'd travelled to, and what they were used for now.
— Nampo, August 2019

Although more modest than the decorations in Pyongyang, Nampo still displayed flags and posters in celebration of 2018's political achievements. — Nampo, September 2018

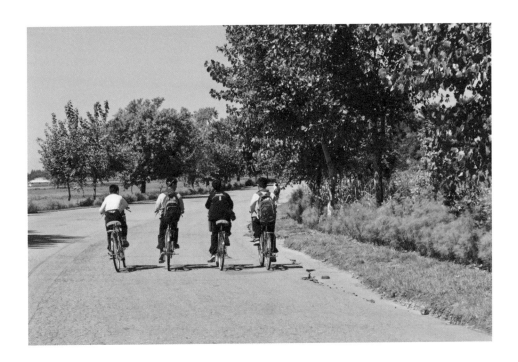

On the country roads leading from Nampo city to the beach areas, apartments and shops disappeared to reveal fields and small villages. This road led past endless smelly salt plains whose water looked sickly grey in the sun. These cycling children pedalled hard through a wall of heat, passing soldiers and children lying by the side of the road in the shade of skinny trees. Heavy clouds of noxious dust and exhaust fumes, belched out by passing trucks, slammed into their faces. The boys were overtaken by a woman pedalling a bicycle, to the back of which was strapped an enormous, screaming pig. Any sense of serenity the boys might have had on their cycle home was quickly destroyed. — Outer Nampo, September 2018

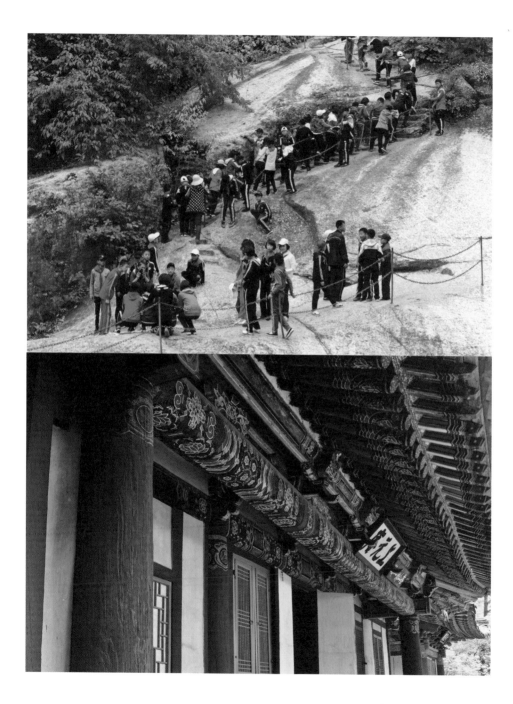

THE FRAGRANT MOUNTAIN

I'd been hiking for around an hour when I came across the third scenic stop on my route: a beautifully painted pavilion perched on the silvery rocks surrounding the base of a waterfall, which looked like the perfect place to recover from the stifling heat and humidity.

Lots of families were hiking and having picnics – with plenty of *soju* – at the stone tables provided at intervals among the trees. One group had even hoisted a karaoke machine up the mountain and were joyously dancing and singing among the leaves. Beer caps tinkled on the tables as the smell of spicy meats and tangy kimchi floated through the air.

While I paused, an elderly woman approached me and asked where I was from. On hearing I was from the UK she said, 'Danny Boy,' over and over again, nudging my arm, winking and laughing. She took me by the wrist and pulled me into a nearby seating area to meet her family. She introduced me to her children, nephews and grandchildren, who all looked a little concerned at having a foreigner thrust upon their day out. One daughter rolled her eyes as her mother explained who I was. 'Off she goes again,' I imagined her thinking.

Encouraged by the old woman's openness and enthusiasm, I asked if I could have a photo with her. She nodded in delight. We sat on a bench and I put my arm around her. It felt like time had slowed. I became absorbed in the feeling of her warm arm under my hand. She smelled of lavender and dried plums. There was so much I wanted to ask and say to her, but we were locked away from each other by a perpetual invisible force.

Without realising, I pulled her in closer to me. She put her hand on mine and tapped it comfortingly. The grandmother bossily ordered the family to get involved and give me a proper cuddle. Emboldened by my permission to take photos, every family member, including the daughter, cheered, took out their smartphones and queued up for a hug and a photograph.

We were all there together. And we weren't. In that moment, I so desperately wanted the rules to disappear and for us all to be free.

(*opposite top*) Children from an activity camp spend an afternoon hiking. — Mount Myohyang, October 2018

(*opposite bottom*) An intricately decorated wooden temple at the top of one of the several smaller peaks on Mount Myohyang. — Mount Myohyang, October 2018

Propaganda isn't just confined to cities; even in remote areas of natural beauty, propaganda is carved into cliff faces and mountainsides. This man was brushing leaves off this steep carving with nothing to save him from a potential fall into the huge ravine below.
— Mount Myohyang, October 2018

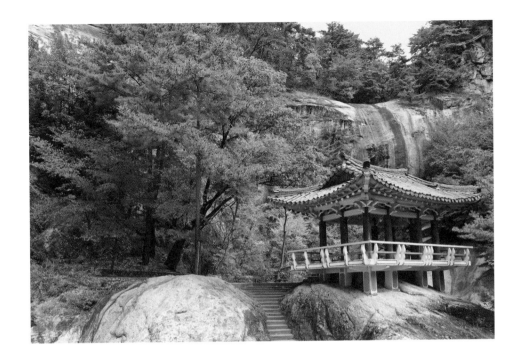

This pavilion, which sits on rocks above a roaring waterfall, is one of Myohyang's many spectacular scenic spots. Wild chipmunks and black squirrels scampered through the trees, while small birds flitted between the branches. North Korea's natural scenery is stunningly beautiful and deeply moving. It was easy to see why so many North Korean people spoke about the country's natural scenery with such pride. However, like many untouched areas of natural beauty in the world, the question of how long it would last was never far from my mind. — Mount Myohyang, October 2018

(*following pages*) Mount Kumgang has been celebrated in Korean culture from as far back as the early Joseon dynasty (1392–1910), whose artists and writers often visited Kumgangsan. The spectacular mountain range is home to 12,000 peaks, from which mighty, roaring waterfalls thrust tonnes of fresh water over silky rocks into deep ravines below. In autumn, Japanese maple trees burst into effulgent, dazzling shades of yellow, orange, red and purple, and ignite the mountain in a fiery blaze of colour. Countless traditional pavilions and temples are nestled in its valleys. It is a place of majestic natural beauty. Mount Kumgang was only possible to visit with the presence of a tour guide or interpreter. — Mount Kumgang, October 2018

ACKNOWLEDGMENTS

Thank you to Hannah McDonald and the team at September Publishing for their unbelievable support, to Friederike Huber for your wonderful design, and to Anne-Marie Doulton at Ampersand Agency for your encouragement and advice. I would also like to thank the following family and friends for their support: my wonderful husband, Mum, Dad and Lewis, Ronnie and Maggie, Tobin James, Maria Brodmann, Aaron Thiara and fellow performers of the RSC summer season 2019–2020 who listened to some of the earlier drafts and were so loving and kind in their feedback. Ayse Osman, Stuart Fleming, Charlotte Peters and all other friends who have not only been so encouraging but understanding whenever I had to hide away to write. Thank you to Sophie Stanton, your friendship and guidance means so much. Thank you to the many other friends and colleagues who have listened, given advice and supported this piece along the way.

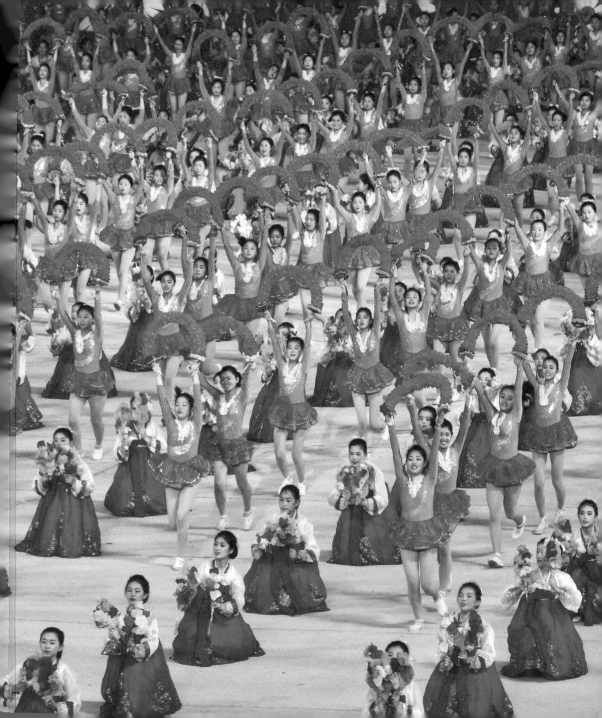

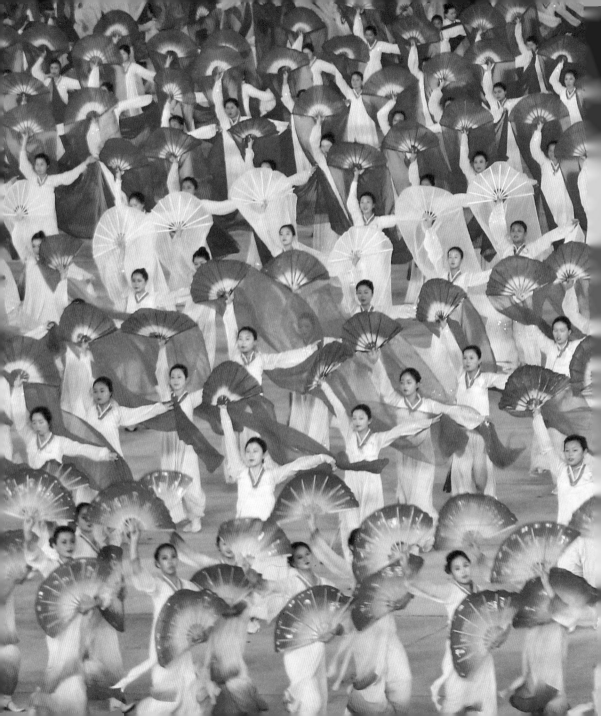